THE ART OF COLLECTING AFRICAN ART

Ernst Anspach
Arman
John and Nicole Dintenfass
Jean and Noble Endicott
George and Gail Feher
Gaston T. deHavenon and Family
Brian and Diane Leyden
Daniel and Marian Malcolm
Franklin and Shirley Williams

Essays by Robert and Nancy Nooter
Introduction by Susan Vogel
With photographs by Jerry L. Thompson

The Center for African Art
New York City

ACKNOWLEDGMENTS

To Mr. and Mrs. Alvin Alperton
in gratitude for the gift of their library.

I am grateful to Andrew Oliver who casually observed to me that private collectors were essential to the vitality of scholarship and museum activity in any field of art— a thought that led to this exhibition. I warmly thank Jay Last for thoughtful conversations early in the development stage that stimulated and helped shape my essay. James Clifford generously gave me advance galleys from his forthcoming book, *The Predicament of Culture* which were helpful in the writing of the introduction. We are very grateful to Robert and Nancy Nooter for their forthright and informative essays on the adventure of collecting. Robert Rubin did most of the selecting and recording of objects for the exhibition with his usual taste and gentle diplomacy. The Center's able staff, Tom Wheelock, Melanie Forman, Carol Thompson, Amy McEwen, and Ima Ebong worked on the catalogue and exhibition, and generally kept the ship afloat while I was otherwise occupied. We are grateful to the Department of Cultural Affairs of the City of New York for a grant supporting the exhibition. Finally, it is to the collectors themselves that we owe the deepest debt of gratitude for consenting to share their experiences, their insights, and some of their finest objects with us and with the public. I thank them all.

S.V.

The Art of Collecting African Art is published in conjunction with an exhibition of the same title organized by The Center for African Art. The exhibition and publication have been partially funded by a grant from the Department of Cultural Affairs, City of New York.

Library of Congress catalogue card no. 88-7253
ISBN 0-9614587-9-8

Photography Credits
All photographs have been taken by Jerry L. Thompson with the following exceptions: Lynton Gardiner, p. 29-33; Peter Moore, p. 42, 43.

Design: Linda Florio
Typography: David E. Seham Associates, Inc.

Printed in Japan

CONTENTS

THE ART OF COLLECTING AFRICAN ART

SUSAN VOGEL

The good collector (as opposed to the obsessive, the miser) is tasteful and reflective. Accumulation unfolds in a pedagogical, edifying manner. The collection itself—its taxonomic, aesthetic structure—is valued, and any private fixation on single objects is negatively marked as fetishism. Indeed a "proper" relation with objects (rule-governed possession) presupposed a "savage" or deviant relation (idolatry or erotic fixation). (James Clifford, The Predicament of Culture)

Rule-governed possession. What are the rules for collecting African art? What kind of taxonomic, or aesthetic structures apply to an African art collection? and what separates it from the random accumulation of African things?

The art we have come to call African consists of a tightly defined segment of the broad spectrum of objects from the African continent. This is no place to attempt a definition of art—a thorny issue which was discussed in The Center's 1988 publication *Art/Artifact*. But even without one, it is clear that African art collections encompass only certain types of objects (mainly figurative sculptures), to the exclusion of most objects (such as baskets) and many art forms (like wall paintings) made in Africa.

The Africa of "African art" is equally restricted. Collections conventionally include art from the sub-Saharan area only, excluding art made in the Maghreb or along the Mediterranean coast (part of an Islamic tradition); archaeological art from Egypt and Sudan (its own tradition); art made by European peoples of southern Africa (part of a Western tradition); and all Modern art from Africa.

Collectors—and museums, the two collect so similarly that by collectors I mean them both—tend to acquire art defined as "traditional," made to serve Africa's ancient cultures. The actual age of an individual work is less important than the degree of acculturation (real or perceived) of the whole tradition from which it comes. Most collectors are drawn to art that seems to reflect a pristine Africa uncontaminated by the influence of Christianity, Islam, or Europe. Although collectors may imagine that their objects date from the last century, research has shown that much traditional art considered to be "old" was actually made during the first half of the twentieth century.

In this respect, the collecting of African art follows long-established Western patterns of collecting what is not only culturally distant, but temporally remote. "This system finds intrinsic interest and beauty in objects from a past time, and it assumes that collecting everyday objects from ancient (preferably vanished) civilizations will be more rewarding than collecting, for example, decorated thermoses from modern China, or customized T-shirts from Oceania" (Clifford, p. 226).

The feeling that the art they own comes from lost civilizations is reflected by the general agreement among collectors that it is not important or even necessarily enlightening to visit Africa. Collectors may be disconcerted by the idea that sculptures like those in their living rooms could be dancing today in Africa. The sweaty reality of use and the sense of things recently removed from their origins affront both aesthetic and ethical scruples. The elevation of African art to a status akin to that of antiquities ennobles and aestheticizes it, and also moves it further from a possibly questionable recent traffic in cultural property, with its sordid implications of theft or purchase at low prices from poor people.

Authenticity in African art is specially defined; the fact of having been made by Africans is not sufficient to make an object "real;" the consensus is that only a work made for traditional use and actually used can be considered authentic. These slippery criteria rest upon accidents of the object's history and the intention of its maker rather than the more usual, and more easily confirmed, authorship and age. As the collectors included here all insist, avoiding inauthentic objects is an unending challenge.

As in Western connoisseurship, the age of an African object is important because the further back in time a culture can be placed, the purer and the more traditional it is believed to have been. An old looking object that is documented to the 1930s or earlier, especially if it can be located in a known prewar collection, acquires special value. Best evidence of all may be the mounting of a sculpture on a base bearing the chop mark of Inagaki, a well known Japanese mount maker who worked for Paris collectors and dealers until his death shortly after World War II. Fake Inagaki bases have already made their appearance on the African art scene.

But age is not enough. The mask carved by a master artist in the nineteenth century, but purchased by a colonial administrator before it was used, is undeniably old but not a desirable object for collectors no matter how beautiful. It might even be identical to a mask carved by the same artist, used for dances by his people, and sought by collectors. The first mask would be rejected because it looked fresh and unused while the second would be prized for its patina of age and signs of wear. Similarly, a mask made by a carver for sale to tourists, but taken up and used by a local masquerade society, would not be considered desirable no matter how old it was, if its creation for a nontraditional client could be detected in its style or finish.

A seemingly arcane value system, peculiar to the African field, rejects whole classes of authentic objects, and large categories of old objects. By and large, collectors ignore authentic works that depict or use elements imported from Europe—such as enamel paint or images with clothes, cars, crucifixes or the like—whatever their age. They also generally prefer the style of earlier pieces to similar later ones; occasionally when there is no evidence about the sequence of styles, those deemed less successful will be considered newer, lacking that "gutsy tribal feeling". In fact, many African carving traditions are still vigorously alive, though they are producing few works that rival the greatest of the past.

These rejected works are not, properly speaking, fakes. Many gradations lie along the path from "real" to "fake" in African art, but by the definition I prefer, a fake is an object that was made to deceive, a forgery. Most are newly carved and artificially aged, damaged, or given old looking attachments. This kind of fake, made in Africa and increasingly sophisticated, is the worry of most collectors. Other kinds

incorporate parts of authentic objects. Lying in wait for the unwary are old but uninteresting objects recarved to become fancier, more imposing, more saleable; pastiches which combine parts of different authentic sculptures into a single work; as well as restored, "improved" objects and other aberrations. As African art has become more valuable, ever greater efforts on the part of the faker are encouraged by ever rising prices: for the collector, buying a fake has become more than disappointing, it can be terribly costly.

What kinds of people venture into the collecting of African art? It has always been a difficult field to master: the artists were anonymous; the collection histories of objects were short and hard to trace; the objects were mostly wood and not old enough to be dated by a laboratory; the bibliography was small, polyglot, and scattered; sources for objects were obscure; knowledge was dispersed and authorities were few. African art never carried the kind of prestige and automatic recognition available to collectors of better known art styles, and visitors to the collector's home were as likely to express polite surprise as admiration at the African art they saw there. These conditions have changed—and continue to change—but the fact remains that it is not easy to collect African art and the rewards are not the usual ones.

"Whether a child collects model dinosaurs or dolls, sooner or later she or he will be encouraged to keep the possessions on a shelf or in a special box or to set up a doll house. Personal treasures will be made public . . . the collector will be expected to label them . . . to tell 'interesting' things about them, to distinguish copies from originals" (Clifford p. 223). Licit collecting entails display and the sharing of one's personal treasures with others. The collector should participate in museum exhibitions, and show the collection to interested people. To do otherwise is to be a miser. African art collectors have often gone further—have organized themselves into groups sponsoring lectures and programs; most have been ready, even eager to share their objects with others who will appreciate them.

The other quality of licit, rule-governed collecting is the responsibility to know. The collectors here all feel it is imperative to study, form a library, to do what they call "homework." Both the need to know, and the need to share are particularly sharp for collectors of African art because of their sense of themselves as engaged in a difficult and unpopular undertaking.

Collectors, passionate about their love for African art, have often had a missionary zeal about promoting general recognition for it. Thus far, institutions have had less influence on African art collectors than the reverse. More often than not, it has been the collector who led the institution (museum or university) to become involved in African art. The institution in turn influenced the general public.

The collector's crucial role in promoting understanding and popularization of African art has been greatly undervalued. Had there been no private collectors, scholarship and publications would necessarily have been addressed to the small circle of academics, or to the school system. Publications would have been infrequent, expensive, small editions. They would never have reached the general public.

As lenders and as supporters, private collectors have frequently been the impetus behind museum exhibitions of African art. In the early days they—along with artists—were the principal audience. Later, museums presented exhibitions to satisfy the urgings of trustees and community members whose personal interests—more often than not—had developed through their contact with the African art they saw in private homes. Until the 1970s, except for sporadic art exhibitions and natural history museum displays in a few large cities, little African art was to be seen in America if it was not in private homes or galleries.

To name only the most conspicuous, Nelson Rockefeller, who began as a collector in the 1930s, persuaded the Metropolitan Museum to accept his collection and create a wing for it. In so doing, he induced one of the country's leading museums to venture into the field. Another farsighted collector, Maxwell Stanley with his wife Betty, not only gave the University of Iowa Museum of Art their considerable collection but persuaded the University to undertake a serious commitment to teaching African art.

The impact of the Rockefeller and Stanley initiatives (and there are many others who could be cited here) extends far beyond the institutions with which they were involved: when the Metropolitan so prominently acquired African art, museums everywhere felt the appropriateness of African art in an encyclopedic collection; the students trained at the University of Iowa, and the publications created there will influence institutions and scholarship all over the country.

The sociology of African art collecting remains to be written, but in general, collectors of African art have been an intrepid and unconventional lot. My sense is that they are more passionate and adventuresome than collectors of other art. In their lives and in their politics they are probably more independent and less conservative than their peers; many are professionals, especially psychiatrists; most earned their fortunes—disproportionately few African art collections have been made with inherited wealth; quite a few deployed modest means to form vast, valuable collections.

African art is one that inspires deep passions. A whole mythology about its place in the human psyche has accrued. African art is said to reach deeper into the intimate emotions, and to expose more disturbing psychological truths than any art created before the twentieth century. Some say Africa is the last place on earth where God spoke to man and they see in her art the expression of an ancient wisdom lost to our civilization. Is this what drives individuals to collect African art?

Collectors speak of their collecting as of a profoundly private passion, as of a love affair, a religious quest, or a deeply pleasurable secret. One entirely sane and stable man confessed that he would surely have left his wife, his job, or his home if he had not had the adventure of collecting in his life. Another, an aggressive and successful businessman, quietly told me—most uncharacteristically I thought—that African art was the closest he would ever come to God.

Whatever their motives, private collectors have played a crucial but undervalued role in bring African art to the general public. They are in great measure responsible for the growth of understanding and the popularization of African art that has taken place throughout this century. As much as the rare institutions that have been active in the field, they have been responsible for the dissemination of information, for the development of real connoisseurship, and for drawing the attention of a wider public to this art.

COLLECTING AFRICAN ART
Two Personal Viewpoints

ROBERT NOOTER

There are many different reasons for collecting art. One is the thrill of the search—it is like having an Easter egg hunt 365 days a year. Finding outstanding objects requires both skill and determination. The sense of adventure is part of the appeal, but there are other reasons. Every day of my life is enriched by having African sculpture around me, as good pieces grow better with every viewing. I enjoy them each evening when they are waiting for me to return from the office. I get a special pleasure from seeing them in the light of the afternoon sun on weekends and holidays, and I visit with them as with old friends when I return from a trip. They elevate the spirit and soothe the soul as the harmony in the artist's nature is transmitted through his work to me. That, for me, is the real satisfaction of collecting African art.

Collecting over the past twenty-two years has added an important dimension to our lives. Little did we know when we paid fifteen dollars for our first African mask on the streets of Monrovia in 1965 that in the years ahead we would spend a substantial portion of our time in various activities related to this fascinating subject. From that modest beginning has come more than two decades of adventure, scholarship, and friendships around the world.

Collecting art appeals because it requires the exercise of both intuitive and intellectual faculties. The collector must have an "eye", but the ability to make aesthetic choices will founder unless one does some homework. A perceptive person will soon learn something about the art, and the culture as well.

Must one collect in order to learn about the material, and to observe this aspect of another culture? Of course not, and most people who study other cultures do not. But acquiring an object concentrates the attention admirably. As the Spanish writer Ortega y Gasset commented about a lover's perception of his beloved, the contemplation of possession intensifies powers of observation. Once owned, the object is subjected to another evaluation in the light of the reality that with selection comes commitment. Suddenly all other objects like the one just acquired become part of an intimate frame of reference, and a little galaxy is created in the mind that includes all of these other objects and the one newly acquired. And so it goes—the little galaxies expand like the cosmos as a collection expands, and then the galaxies begin to find a relationship in the larger universe of art.

The aesthetic, of course, is the heart of the matter. What is in African art that draws people with different cultural roots to it? The force behind its attraction springs from the premise that the art of Africa has a unique aesthetic that both reflects and illuminates the culture from which it comes, and transcends its culture to bring delight to those outside it. It shares with other traditional arts a sense of "rightness", a harmony of form and spirit, presumably because it expresses a culture in harmony with itself. Each member of an African society knows where and how he fits into it, what he may expect from it, when and how he will advance in it, and what its rules are.

Beyond this, African art presents an astonishing number of aesthetic qualities in its forms and expressions. Power, mystery, and beauty are united with inventiveness and purposeful distortions, as the African artist finds unique ways to give expression to his craft while remaining within the strict limits of his group's artistic traditions. Metamorphosized forms, exaggerated or minimalized body parts, combinations of animal and human features, precision of line, and apparent crudeness of execution all work to excite our senses.

The problem for the collector is to be able to discern when the inventiveness of the carver is appropriately blended with traditional dictates of line and form. The outright fake may be easier to detect than the subtle distortion of traditional forms which results when European influences impinge on the traditional culture. This, and the enormous variety, complexity, and sheer numbers of African traditional forms make it among the most difficult of all fields of collecting. After twenty-two years of intensive effort, my wife and I believe that we are beginning to get the hang of it, but it is apparent now that there is never an end to the learning process.

The world of the collector includes museums, galleries, private collections, libraries, and the halls of academe. Sometimes relationships among the various parts of this world are uneasy, but all are linked in a ritual dance in which the central figure is the art to which all pay homage. The collector stands to benefit most from the relationships, at least until the time comes to make a contribution in terms of knowledge and judgment. But the linkage is essential to all the parties, and all come out ahead if the relationships are open and cooperative.

How well I remember the uncertainties of our early years of collecting. Fortunately we started in Liberia, where the art market was limited to objects from the nearby West African countries. Later, we could build on the knowledge of this relatively small area as our collecting began to include art from other parts of the continent. Mostly, though, we were fortunate in having the helpful and kindly assistance of several of the most knowledgeable persons in the field to guide and advise us.

On our return from our two-and-a-half years in Liberia we stopped at the British Museum, and, with limited time and no advance notice, we asked for William Fagg. We knew him only as the Deputy Keeper of the Department of Ethnography and co-author with Margaret Plass of the wonderful little book entitled *African Sculpture*, which had been our bible in Liberia. We had brought along a Kissi steatite figure that we had acquired, much like one in the museum's collection. Bill Fagg came down immediately and spent an hour examining the figure and some photographs we had taken of our other Liberian acquisitions. This was followed by a morning in the reserves, where for the first time we had an opportunity to see a full range of documented material. This was the first of many helpful sessions with Bill over the years, and we are deeply in his debt.

We also owe much to the help and advice of Michael Kan, then a curator at the Brooklyn Museum, when we began to make collecting forays to the New York galleries in the late 1960s. I recall rousing Michael late one night to show him a Songye Kifwebe mask we had come across, which he wisely advised was authentic but mediocre. And I remember the feeling of pride tinged with anxiety when, after several years of such guidance, Michael declared that our tastes had

developed to the degree that we no longer needed his assistance.

There were many others who were enormously helpful, not the least of whom was Susan Vogel. They include not only museum people, but other collectors and dealers as well. The dealers share the collector's sense of commitment to the art and suffer the same consequent intensity and anxiety, as mistakes for both groups have their financial consequences.

Which brings me to the crass side of collecting African art—it has a financial value, and this adds a commercial dimension to all transactions. This is inevitable as a means of providing a rationing system, as the supply is limited. However, the true collector's motives are seldom financial. Rather, they are related to a desire to possess a beautiful object, and perhaps to demonstrate an ability to select superior pieces from the general mass of material. Doing so with limited means adds to the challenge. Today's high prices make this challenge even greater than in the past. I recall the great art dealer, J.J. Klejman and his wife, deploring the escalating prices of African art in the late 1960s. At the time this seemed strange to me, as their New York gallery undoubtedly had a substantial reserve stock that was increasing in value, but now I share the same view—there was more pleasure in acquiring objects when an important piece could be obtained without committing one's life's savings.

Dedicated collectors, however, can always find pieces within their means. We have received enormous pleasure from small or simple objects with good lines or a good surface, true to their culture and pleasing to the eye. Standards of selection should always remain uncompromisingly high, regardless of the monetary value of the objects one chooses to collect.

A collector's homework consists of seeing as many objects as possible, and objects of every type. A collector may find, for example, the form of an Asante fertility figure pleasing to the taste, but one cannot make a relative judgment about Asante fertility figures without seeing the entire range. The permanent and reserve collections of museums, temporary exhibitions, and objects owned by other collectors can all be helpful in this regard. And although photographs never fully replace direct observation, art books can extend our scope of knowledge. Every collector would be well advised to develop a personal library. Auction catalogues and advertisements in African art journals are other important sources. Objects with dated provenances are especially valuable in providing a solid frame of reference for traditional styles, and in this respect museums are the prime source of information.

Taken all together, these resources become a mental file of the parameters for each type of object, so that one may place each new work of art in an aesthetic context. Over many years, whenever we have considered an object for purchase, we have searched our library for similar works. This was very helpful in evaluating the object we had under consideration. A potential hazard of this approach is that the process may become overly intellectual, even though a background of knowledge is a fundamental prerequisite. But ultimately, the judgment must be an aesthetic one, and homework can carry one only to the threshold of this process. Now, in judging material with which we are familiar, there is an internal "click" when we see an object that meets the standard of quality we have developed over the years. And then seldom will discussion, study, or further consideration change the judgment that has taken place.

Over the years, we tried different methods for reaching decisions about what we should acquire. First, we sought to collect one good example of each type. Then we thought it would be preferable to seek the aesthetically best example of a type, even if the type itself were minor. Neither of these systems proved very useful, and were soon abandoned in favor of obtaining, when possible, those objects that generated the mental "click" of aesthetic recognition, assuming that close examination verified their authenticity.

As our collecting continued, the concept of a "collection" took on meaning. We found that only objects of a certain standard of quality were significant additions to the collection, and we disposed of or set aside lesser pieces. At the same time, we also found that each addition of an outstanding object enhanced the other good material already in our collection. While each good work of art should stand on its own merits, adding an object to a "collection" is something more than just acquiring a piece by itself. A resonance among the objects stirs our senses in a way that adds to the total aesthetic response and makes the whole more than the sum of the parts.

Another important ingredient of collecting is the courage to face up to our mistakes. It is inevitable that one will make errors of judgment from time to time, especially in a field where forgeries are rampant. As no one wants to be the bearer of bad tidings, the experts will be reluctant to point out errors, unless they are thoroughly convinced that we really do want to know the truth, however unpleasant it may be.

I vividly recall our first major lesson in damage control. The National Gallery of Art in Washington, D.C. mounted its first show of African art in January, 1970, and we were fortunate to have a Toma mask, collected in Liberia, chosen for exhibition. Bill Fagg, who had selected the show, came to Washington for the occasion and we invited him to see our collection. Before he began to view our pieces, we made clear to him that we were novice collectors and really did want to know if he found objects that he thought were dubious. After his usual thorough inspection, Bill identified two pieces that were "not right"—they were the two most important and expensive pieces we had acquired up to that time! I will never forget feeling my heart drop to my knees. Bill was complimentary of the rest of the collection, however, and encouraged us to continue to collect. Following the initial shock, we were most grateful to have received this helpful advice before we could make further mistakes. We returned the questionable objects to the gallery from whence they had come, and (eventually) selected alternate and genuine pieces in their place.

Fortunately my wife and I both appreciate African art with equal enthusiasm, although this complicates the selection process, since we do not acquire any major piece that does not appeal to both of us. We decided long ago that our combined judgment was better than our individual opinions, and this policy seems to have raised the level of quality in our collecting. Beyond this, it has been an enthusiasm we have shared with mutual satisfaction.

I do not know how long the collecting of fine objects will still be possible in an age when an increasingly wide segment of the population aspires to collect and is financially able to do so. As traditional art is limited in quantity, and very little new production is going on, the expanding demand (irresistible force) will soon collide with the finite supply (immovable object). In time all of the good material will, and should, move into museums where it will be protected, cared for, and exhibited for everyone to see. But the process is a slow one, and while the rules permit it, collectors will continue to seek and acquire pieces of outstanding aesthetic quality to appreciate and enjoy. In the meantime, collectors are really caretakers of the art works rather than owners, because these objects are part of a great human tradition that belongs to mankind as a whole.

NANCY NOOTER

So elusive and personal is the response to art that discussion of it becomes an equally personal revelation. For me, the most remarkable aspect of collecting African art has been the way in which the appreciation of each object has led to a profound curiosity about its original use and its meaning to those who created it. Ultimately, this has resulted in a persistent quest for information which led me to graduate school, field research, and what promises to be a lifelong romance with the ideas that inform this compelling art.

From my first exposure to African art in Liberia in the sixties, my response was a purely aesthetic one—I found it powerful, irresistible, and strangely moving. But soon even that was not enough; it was necessary for me to know more. I was driven to try to learn how these objects functioned in their parent societies, to discover who used them, why, and what the surrounding historical circumstances were. Unfortunately, it is not possible to place each work of art in all such contexts, but by keeping up with the continuing field research of scholars and by gathering oral histories, I found knowledge can be greatly increased.

The process of acquiring collectors' skills influenced many facets of our lives. I recall my feelings of uncertainty when I learned in 1979 that my husband had been assigned to Tanzania, and we would live there for a period of several years. It meant that I would be obliged to leave my job at the Museum of African Art, and the graduate program at George Washington University, which I had nearly completed except for the research and writing of my Master's thesis. Tanzania seemed to offer little of interest in traditional art, and I asked Douglas Fraser of Columbia University, who had agreed to be one of my thesis readers, what I should do there to further my studies. He replied, ''Keep your eyes peeled.'' As it turned out, that was good advice, for in Tanzania we began to discover artistic riches beyond our dreams.

What these art traditions would be was not immediately apparent to us, for they did not usually take the form of sculpture in wood. Rather, as we gradually discovered, there were very old traditions of architectural ornamentation along the Swahili Coast, especially in Zanzibar, and rich prehistoric rock art throughout central Tanzania. We found there were extraordinary examples of body art among the Maasai, Mbulu and other pastoral groups, and high levels of artistry

in the basketry of the Hehe and Haya. The Makonde still danced traditional masks, and the Zaramo and related groups continued to utilize small sculptures in their initiation ceremonies.

Three of these art forms were of particular interest to us, not to collect, as they were not collectible, but to study and appreciate. We made expeditions throughout Tanzania to look at the art, observe the traditions, ask questions, and take photographs.

The great carved doorways of the Swahili Coast were the first to capture our imagination. Their grand size, their beauty, the craftsmanship of their carving and its exquisite elaboration, their symbolic motifs, and their long and complex history all fascinated and appealed to us. We made a number of trips to Zanzibar and to Bagamoyo to see the doors and to photograph them. Research into the history of their origins and their evolution, their design and motifs, created a sense of excitement and discovery and promoted intellectual as well as aesthetic stimulation.

Our next adventure was the discovery of the rock art of central Tanzania, whose origins are estimated to date back more than 25,000 years, placing it among the oldest art traditions in the world. The sites are in remote areas, difficult of access, requiring long hours of travel over barely passable roads and much climbing on foot. But the lure of these ancient paintings with their enigmatic messages is powerful, and it was worth the effort to seek them out. The multiple layers of painting represent different styles and periods, incorporating many techniques and degrees of naturalism. The latest of them, possibly executed as recently as A.D. 1500, are abstract and painted in white.

Henry Fosbrooke and his wife Jane, working in the 1950s, were among the first to find, document, trace, and classify the central Tanzanian paintings. While we were in Tanzania they were still living near Arusha, and were most helpful to us in offering information about the paintings, as well as hospitality, warm friendship, and good conversation. Our visits to their charming cottage overlooking a crater lake, with Mount Kilimanjaro visible in the distance on a clear day, were always a delight.

The third form, the body art of Tanzania's pastoral peoples is still very much a living tradition. We made many journeys to Maasai settlements to visit with the people. These experiences excited our interest leading us to read and learn a great deal about Maasai life and the significance of their customs, their extraordinary beadwork, and their other art forms.

The Tanzania experience also affected our collecting of wood sculpture in indirect ways. Because of our heightened awareness of Tanzania's manifold art forms, we learned about its sculptural traditions as well. After leaving Tanzania, we acquired a number of such works through dealers or auctions in Europe. Our interest, sparked by what we saw in Tanzania's museums and the literature pertaining to East African sculpture, inspired us to further studies which later helped us to make relatively informed decisions about this art.

Unquestionably, our earlier exposure to other types of African art through our years of collecting and studying had attuned our senses to seek out the less obvious art forms in East Africa, enriching our time there immeasurably. Finally, I was able to record an oral history, which gave fascinating

background on Swahili attitudes and culture, and this became the basis for my Master's thesis, rounding out a rewarding cultural and aesthetic experience.

The Tanzanian years produced another result that proved to be profoundly gratifying. Our daughter Polly, at that time an undergraduate student, spent two summers with us there, joining us on many field trips. She was thinking about her future, and because of those visits, decided on graduate school in art history specializing in African art. She is now a Ph.D. candidate at Columbia University and conducting her fieldwork among the Luba people in Zaire. Before her departure for her field studies she had several highly rewarding and educational years as a member of the staff of The Center for African Art.

All of us respond to art in our own individual ways. The two principal approaches, aesthetic and inquiring, serve as the basis for the distinction between connoisseurship and scholarship. As Susan Vogel observed in an essay for *African Arts* IX, 3, they are two different things, and are not necessarily both to be found in the same individuals. Scholars, virtually all of whom have worked in the field, are concerned with the context and meaning of art forms and the traditions from which they spring. Many employ the technique of stylistic analysis to enable them to locate works in time and space and, in some cases, to read meaning in form or iconography. This presumes a thorough knowledge of the cultures in question and their traditions.

The connoisseur's approach, on the other hand, places aesthetic quality first. Indeed, this viewpoint can—though certainly does not always—ignore context and usage altogether. The late Robert Plant Armstrong discussed this perspective in *The Affecting Presence* in which he referred to the affecting object as perpetual and complete within itself, with the power to stir the person who perceives it. He considered an affecting presence to be universal as well as cultural and particular, because all art is a depiction of, a variation upon, or an abstraction from, the perceivable world.

Jacques Maquet presents another approach, the idea that we have "created" art out of objects that simply had religious use or significance in other cultures. Such objects were not thought of as art within their own settings, certainly not in the sense that we know it, but rather as media through which a desired result could be produced.

The connoisseur's approach is essentially an emotional one. But a true connoisseur is informed, not only in the aesthetics of what constitutes excellence of line, form, mass, volume, and surface, but also in the knowledge of an object's origin and traditional use. Museum personnel must combine the expertise of both the connoisseur and the scholar, for with them rests not only the responsibility for the presentation of the best material, but also the interpretation of it.

A true connoisseur, as distinguished from a dilettante, must have a command of the available data and knowledge as well as an understanding of the subtleties of object types and an ability to distinguish between acceptable variations and those that are aberrations. As my husband has observed, one must be faithful to the demands of truth and be unafraid to alter one's opinion of an object in the face of new evidence.

This brings us to one of the most important problems of all, authenticity, for nothing else matters if a piece is not authentic. Scholarship enables one to discern authenticity through an awareness of how an object should look if it fulfilled its original function. Use could determine its size and design, and of course, its patination. The approach of scholarship is generally through first-hand observation of art in the context of its traditional use, along with concentration upon form and iconography. In this approach, aesthetic qualities may or may not play a part in the understanding and assessment of an object. But many scholars are indeed mindful of and sensitive to aesthetic standards and recognize that the African artist also had criteria for visual excellence.

While making aesthetic judgments involves an emotional process, determining the authenticity of an object is a purely intellectual exercise that draws upon all the information that can be mustered. The prevalence of fakery is old news to anyone acquainted with this field. The forgeries range from inept and easily detectable, through competent, to superb and virtually undetectable. And inevitably, the most accomplished fakes often appear to be the most important and desirable pieces.

So much has been published on the problems of fakes and forgeries that I can only suggest that the reader refer to library listings and become familiar with this valuable information. One of the most accessible treatments of the subject is in *African Arts* IX, 3, an issue devoted to this topic, in which many recognized experts in the field, including scholars, dealers, and collectors, offer observations, comments, and advice.

I strongly agree with Roy Sieber who, in lectures and publications over the years, has set out very helpful guidelines for the selection of fine and authentic African art. In brief, he has maintained that a work must have been made using traditional materials and techniques, utilized within a traditional context, and must bear the signs of age and of use within its culture of origin. A work should be central to a recognized style or substyle, or within the range of its known variations. Better still would be an object by a known hand, of whom other works are recognized. And from this we can infer another requisite, that the work was of aesthetic value to its parent culture, and deemed good enough to use. Where an historical sequence is known, a piece should be located in it. Only after satisfying these criteria can a work be judged on the aesthetic qualities that meet Western requirements of artistic excellence.

On the whole, I prefer to approach African art with the attitude of a student or scholar rather than as a collector, although I enjoy and try to practice other means of involvement with the art. I agree with my husband that the masterpieces of African art should someday rest in the public domain where they will be accessible to everyone who may see them and be moved by their affecting qualities. There they will assume their rightful places as African representatives amid the great artistic heritage of mankind. But I am also aware that collectors play an invaluable part in the process of building museum collections through their interest and appreciation of art, as well as through more direct means. And I am mindful that my scholarly interest in this art, which has provided me with some of the most rewarding experiences of my life, is rooted in my initial exposure to it as a collector.

ARMAN

It was at the flea market in Nice that Arman acquired his first piece—a Dan mask, which he has since sold. Arman began putting together his collection of approximately seventy pieces in the early 1950s, but acquired most intensively during the 1960s. He realized at this time that what had begun as a random acquisition of objects had turned into the formation of a collection.

"Economy of means for a powerful result" is the way Arman expresses the quality of African art that drew him to collecting. He is interested as well in the meaning of objects that might have had a social or religious function.

The focus of Arman's collection is centered on the art of Gabon and Zaire. He likes to acquire groups of pieces that are alike. He calls these groups "accumulations" and determines what he will buy for the collection according to what works will fit into such a grouping. This criterion for collecting relates to the other categories of art he collects—all types of objects—knives, radios, and modern works by such artists as Marcel Duchamp and Kurt Schwitters, artists known for their assemblages and collage pieces.

Arman has been to Africa, but believes that visiting the continent is not particularly important to collecting African art if the collector is knowledgeable about the type of art being collected. To a new collector he would advise, "Look for the culture, not the fashion of the collecting trend when choosing a piece. Follow your instincts and what *you* like."

In addition to buying objects that relate to others already in his collection, Arman also buys on the basis of the quality of a piece. For Arman, the greatest satisfaction of collecting African art is that of assembling a very fine collection.

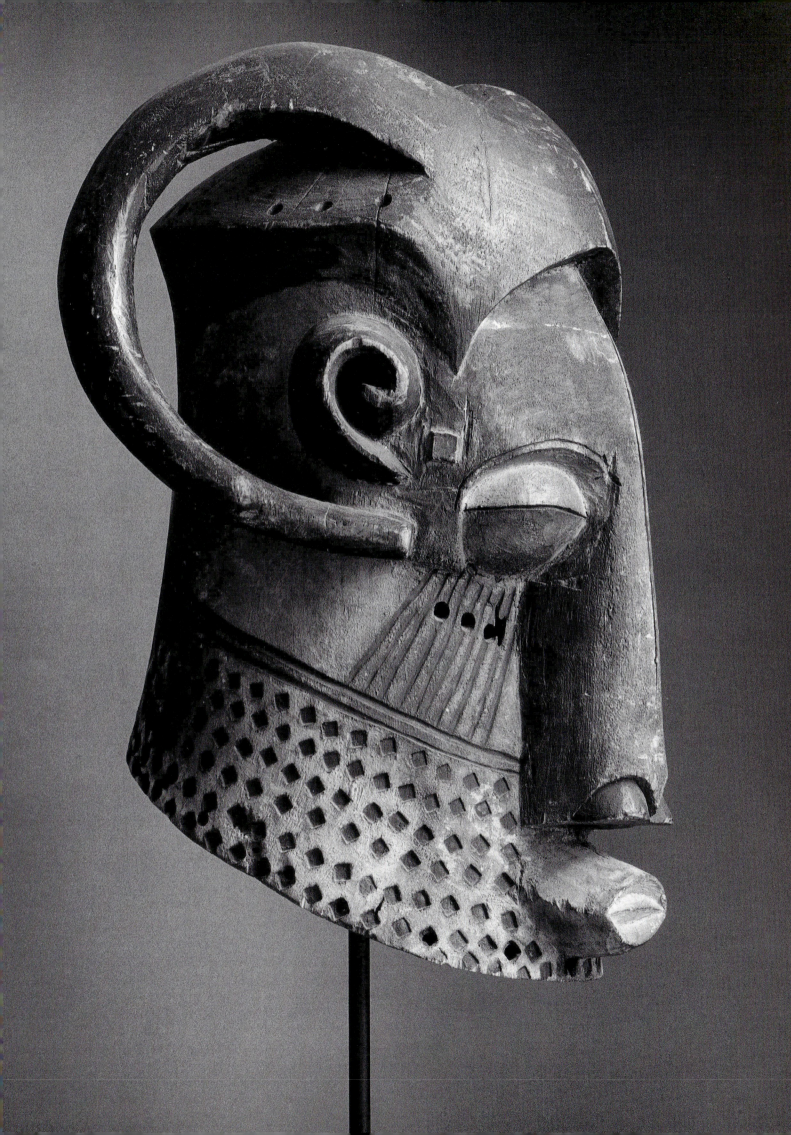

Helmet mask
Zaire, Kuba
Wood, pigment. H. 19 in.

Stylistic features of this mask,
including the patterned poly-
chrome of the lower horizon-
tal band, the diagonal lines
incised across the cheeks,
and the curvilinear forms of
the upper portion, identify it
as of the Kete Kuba substyle.
It would have been worn at a
funeral celebration in honor
of the spirit of a notable.

Reliquary guardian
Gabon, Fang
Wood. H. 18 ¾ in.

With hands clasped at the
waist, this self-composed
looking figure once guarded a
reliquary which contained the
skulls of important ancestors.
It does not represent a single
individual; rather, a group of
ancestors is represented col-
lectively in a single image.

Neckrest
Zaire, Shankadi
Wood, beads. H. 6 ¼ in.

A headrest is used for sleep-
ing in parts of Africa where
men and women wear elabo-
rate coiffures, such as the
cascading hairstyle seen on
the figure here.

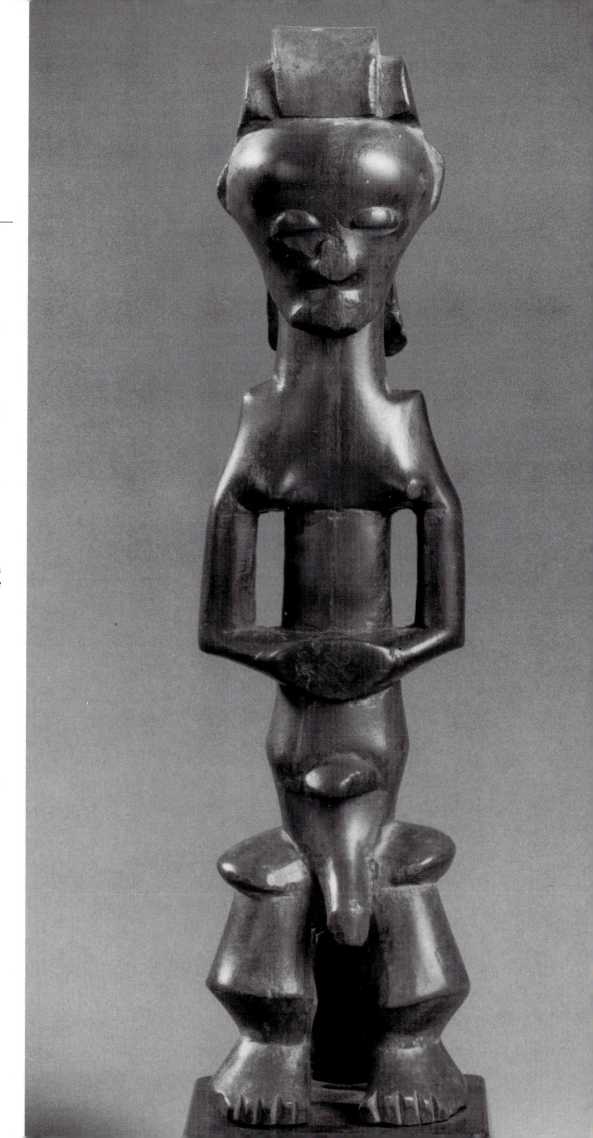

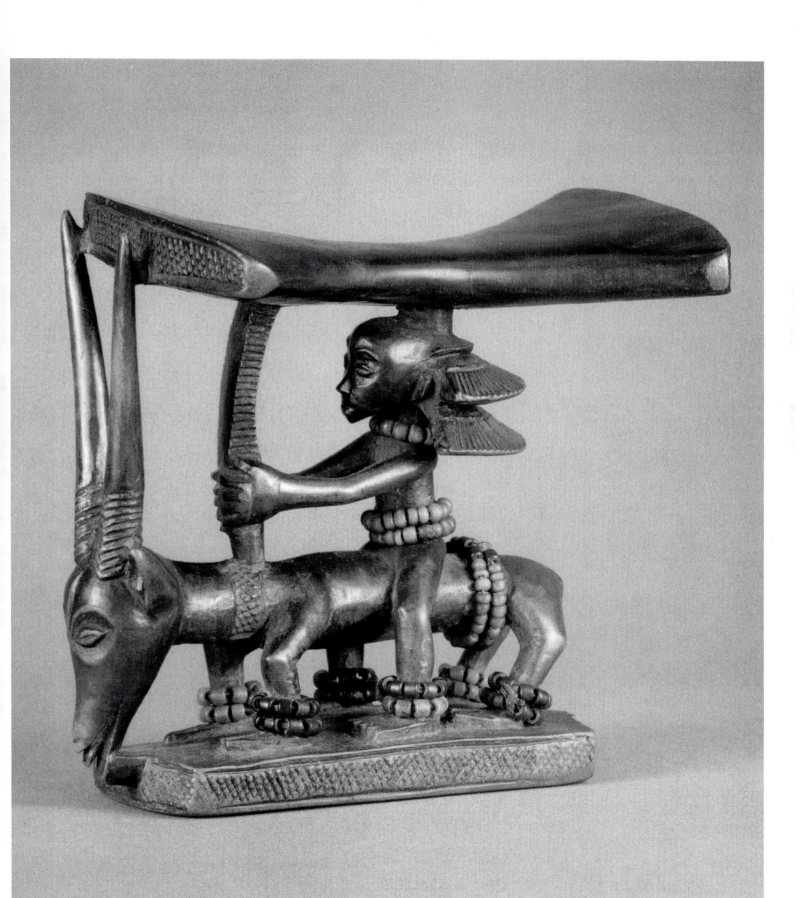

Reliquary guardian
Gabon, Fang
Wood. H. 16 ¼ in.

This figure, like all Fang reli-
quary heads and figures, was
made for a family cult in hon-
or of ancestral spirits. By ad-
dressing the relics kept under
the figure, living descendants
could seek the aid and bless-
ings of their forebears.

Reliquary guardian
Gabon, Fang
Wood, metal. H. 15 ½ in.

This figure may have been
made by the same artist who
carved the full figure, now a
fragment, in the Carlo Mon-
zino collection.

Headdress (not illus.)
Nigeria, Boki
Wood, rattan, fur. H. 8 in.

Reliquary guardian (not illus.)
Gabon, Fang
Wood. H. 15 ½ in.

Power figure (not illus.)
Zaire, Songye
Wood, feathers, beads,
metal, horn, resin.
H. 35 ¼ in.

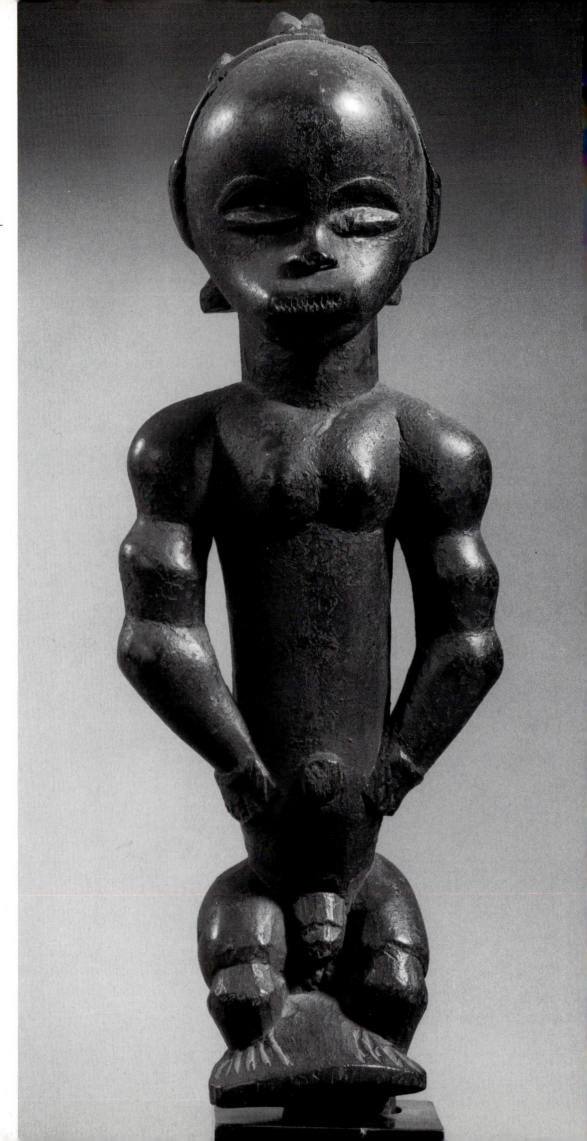

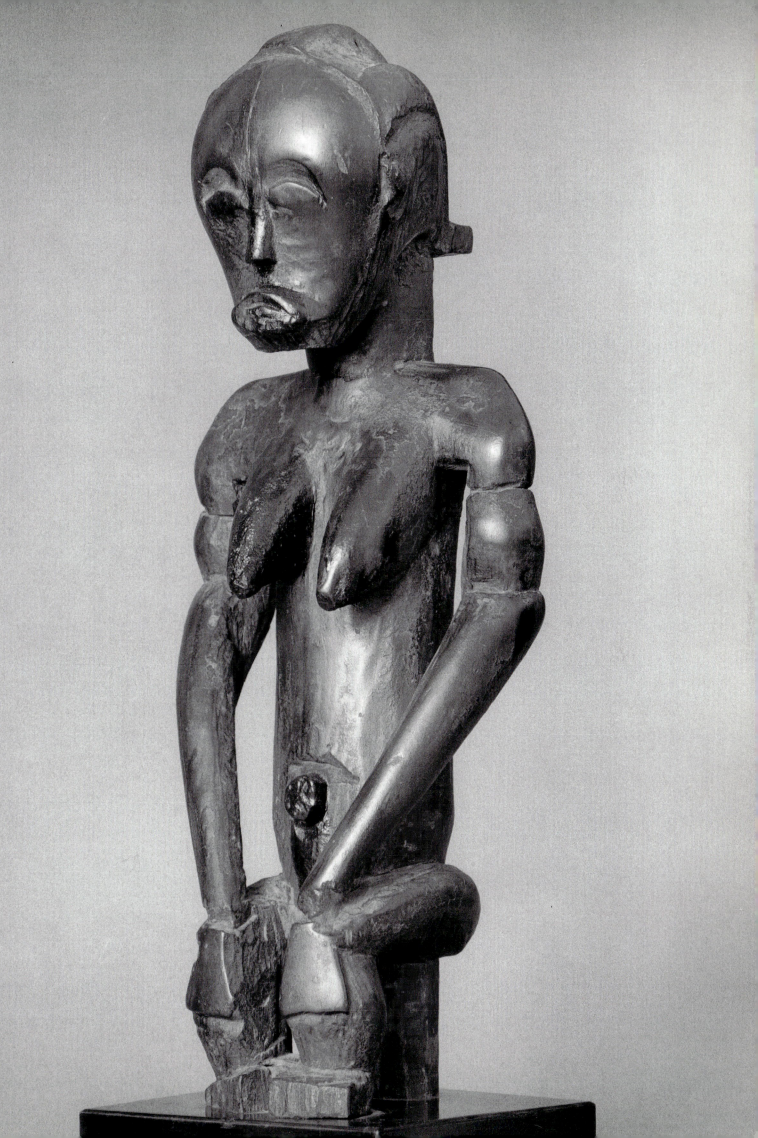

"The objects themselves are
the ultimate satisfaction!
The discovery of new ob-
jects in unexpected places
is continually a high!"

GEORGE AND GAIL FEHER

The first piece of African art Mr. Feher collected—an object which he purchased from a dealer—can now be seen at The Metropolitan Museum of Art, to which he donated the piece. The Fehers have twenty pieces in their collection, formed primarily during the years 1978–1981.

It was Mr. Feher's initial exposure to a friend's fine collection of African art and its immediate aesthetic appeal that led him to collect it—randomly, at first, and then with more intensity. The selection of pieces for their collection is based purely on the aesthetic appeal of the object rather than on its geography, tribal origins, ethnography or function. They continuously look at and reevaluate their collection and select new pieces in terms of "adding to the collection." Works that do not provide ongoing "appeal" are either traded, sold or donated. The Fehers prefer to collect selectively, acquiring fewer objects, and demand more from each object. Ten years ago, the collection was three times its present size; now it has become "a smaller, but more satisfying collection."

"While form, for us" Mr. Feher says, "is ultimately the main element, the African context is important to know. As with any art or subject, the greater one's background, experience, exposure, the better one is able to evaluate and understand the material."

To learn the process of collecting, the Fehers recommend: "Visit collections, read, attend auctions, talk to experts, haunt museums. Do not purchase rapidly, and seek advice on what you have purchased. Ask for honest advice, and don't be insulted or angry when you get it."

For the Fehers, collecting in itself represents much pleasure, yet, the contact with other collectors, dealers and experts adds immense enjoyment, as each has a love of the art which enriches the "sport" and the "obsession."

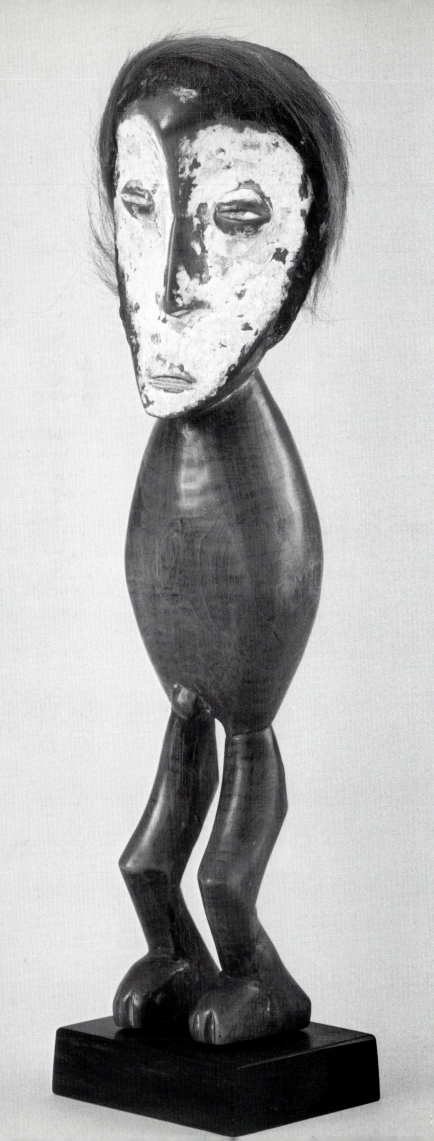

Armless figure
Zaire, Lega
Wood. H. 10 ½ in.

While the significance of any given Lega work of art varied according to the way it was used or displayed, some object types are consistently associated with negative or positive ideas. Disfigurement, here the lack of arms, is negative and usually refers to a transgression of the law—adultery, theft or general misconduct. This figure was a didactic device for teaching the Bwami social and moral code.

Bird
Ivory Coast, Senufo
Wood, pigment. H. 54 ½ in.

Monumental hornbill sculptures are used by the men's society, Poro. The bird's form and the polychrome patterns painted on its outspread wings carry multiple meanings which only senior initiates fully understand.

Male figure
Ivory Coast, Baule
Wood. H. 20 ½ in.

This figure was probably created to appease a spirit husband. The Baule believe that everyone, before birth on earth, had a spouse in the other world, and that these spirit spouses may become angry or jealous and disturb the lives of their living partners.

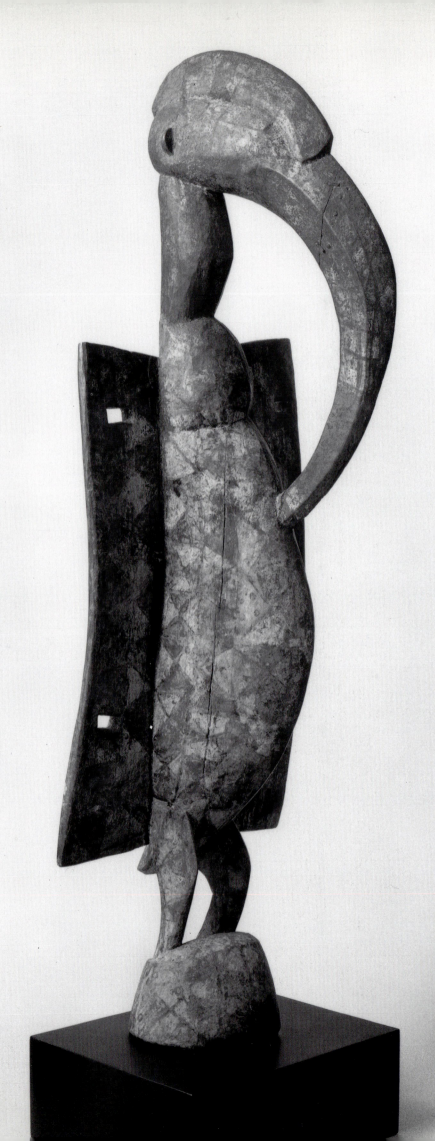

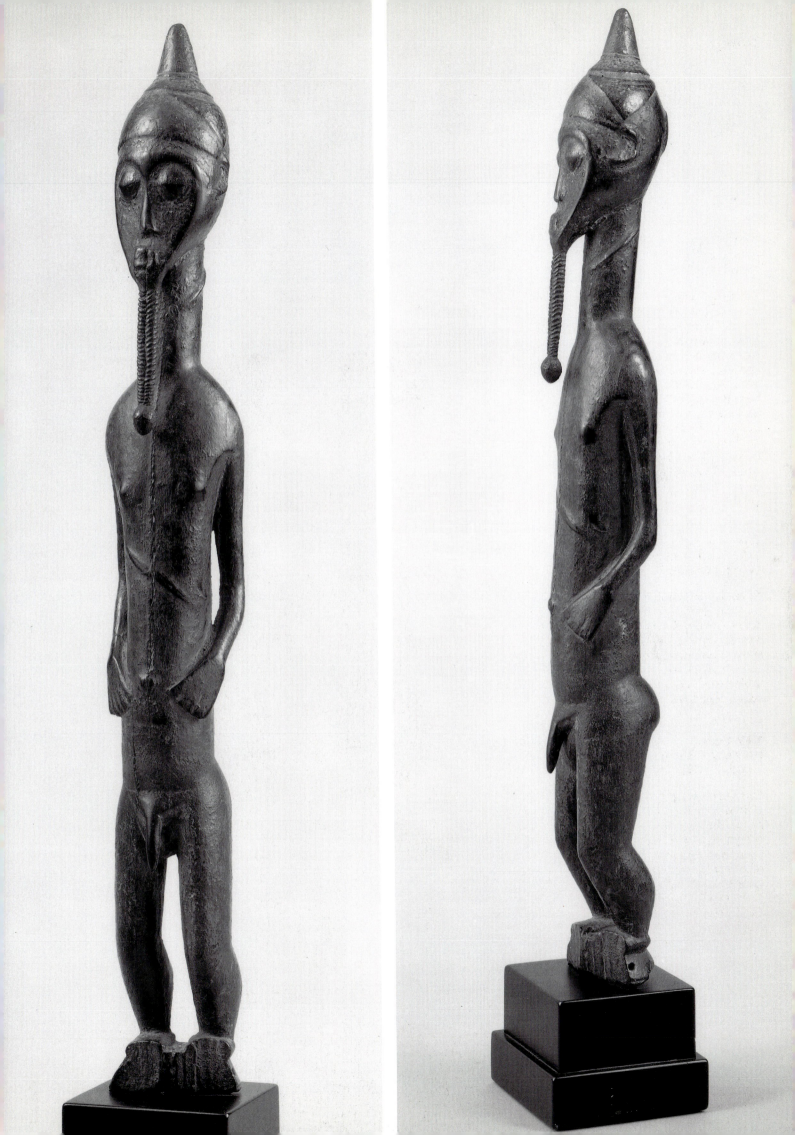

Female face mask
Ivory Coast, Dan
Wood. H. 9 ½ in.

The extraordinary symmetry of this mask would have been prized by the Dan. Dan artists interviewed by a Western art historian listed symmetry as among the most important features which make a work beautiful.

Staff
Zaire, Luba
Wood, metal. H. 66 ½ in.

Staffs adorned with figures were part of the regalia displayed by Luba chiefs who traced their lineage through maternal ancestry. This accounts for the importance of women in the imagery of status defining objects.

Abstract mask (not illus.)
Nigeria, Afikpo Igbo
Wood. H. 10 ¼ in.

Power figure (not illus.)
Zaire, Kongo
Wood, feathers, mirror, resin.
H. 11 ¾ in.

Standing figure (not illus.)
Angola, Chokwe
Wood. H. 8 in.

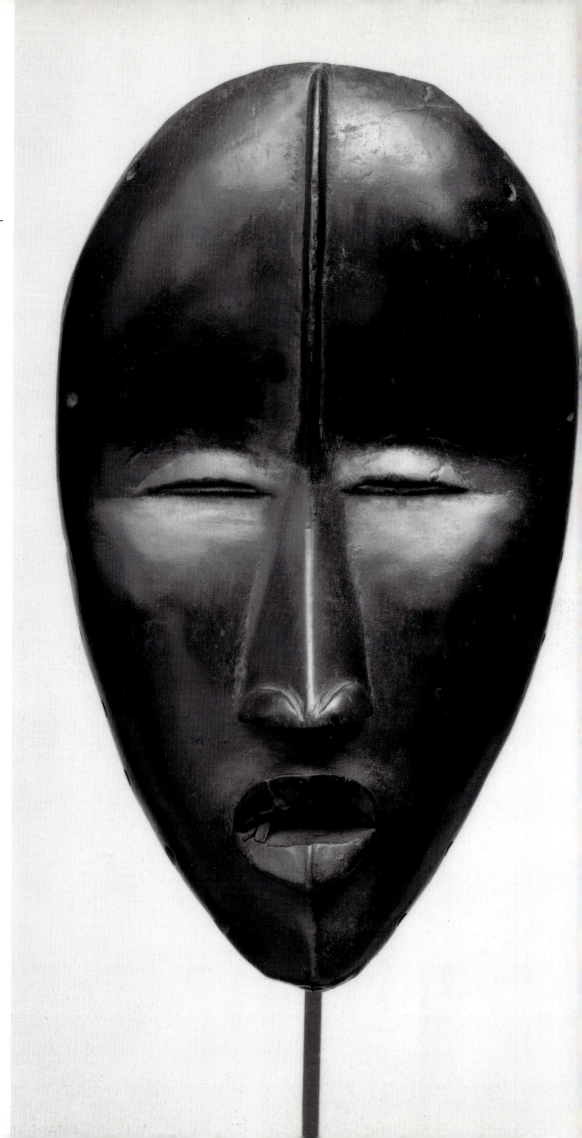

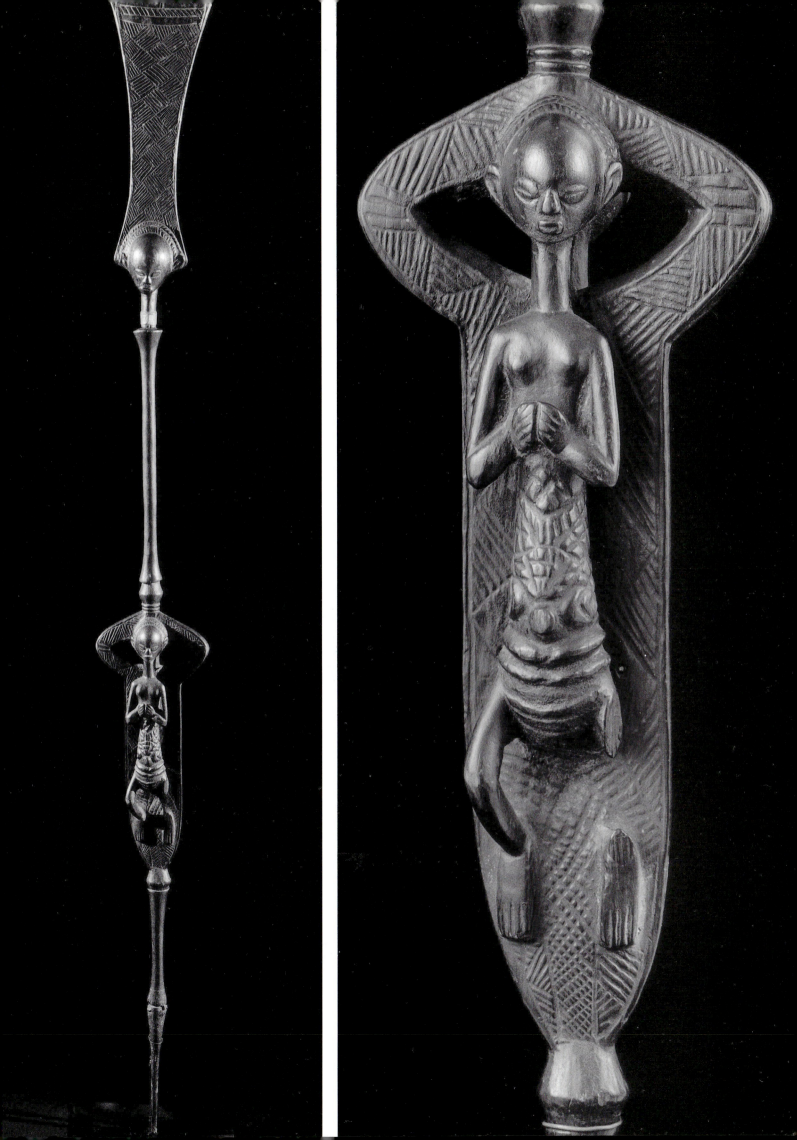

DANIEL AND MARIAN MALCOLM

The Malcolms acquired their first piece in 1961. They had been intrigued by an exhibition of African Art in Paris and once back in New York City started to go to the galleries. Finally—for their first purchase—they bought a Baule mask. Over the years, as their knowlege and taste improved, the mask departed as they "traded up."

The Malcolms are not clear about what it was that drew them to African art. "Most people come to African art through an interest in Modern art. With us it was the reverse—African art started us looking at other art. We still respond most viscerally to African art."

The Malcolms collect with equal enthusiasm—and both have to love an object in order to acquire it. However, they differ in the criteria by which they evaluate an object. Pure form is the primary element for both of them, but for Dr. Daniel Malcolm, the context is important, whereas for Dr. Marian Malcolm, it is not. They are guided by the standard of buying only what they want to live with—but buying the best quality possible.

Although the Malcolms have been to East Africa—the "standard sight-seeing safari"—they state that they would be collecting African art even if they had not made the trip. They have found that their taste has become more sophisticated over the years, adding that years ago "we would not have seen the beauty in many objects we love today."

Most collectors are ambivalent about lending their works to exhibitions, and express their dismay at having to live without their pieces for a length of time. The Malcolms feel differently: "We lend to exhibitions when we are convinced the pieces will be well cared for. We enjoy seeing and we enjoy sharing."

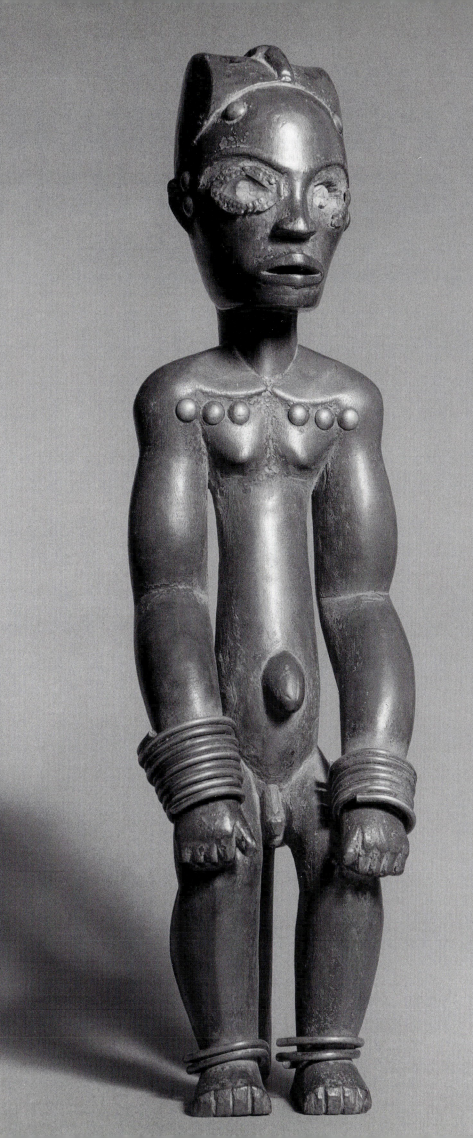

Reliquary guardian
Cameroon, Bulu
Wood, metal, glass, brass
tacks, teeth. H. 16 ¼ in.

Identified as Bulu, this figure
served the same function as
Fang reliquary guardian fig-
ures. Stylistically, Fang and
Bulu figures closely resemble
one another, though Bulu fig-
ures are more naturalistic,
often have applied metal dec-
oration, and may be aggres-
sive looking with open
mouths and piercing eyes.
This figure's eyes consist of
human molars inserted into a
hollow and covered with
glass.

Bell: mother and child
Zaire, Kongo
Wood, metal, cane, rattan.
H. 7 ¼ in.

This bell probably once be-
longed to a ritual specialist—
a healer or diviner—who
used it to summon spirits
from the other world.

Pipe: figure on hand
Zaire, Lulua
Wood, metal. H. 10 ¾ in.

Decorated pipes and mortars
used for the smoking of hemp
and tobacco became com-
mon among the Lulua during
the late nineteenth century
when the ruler Kalamba Mu-
kenge forbid the drinking of
palm wine, promoting smok-
ing instead. The left hand,
generally associated with pol-
lution in Africa, is usually
used for taking tobacco.

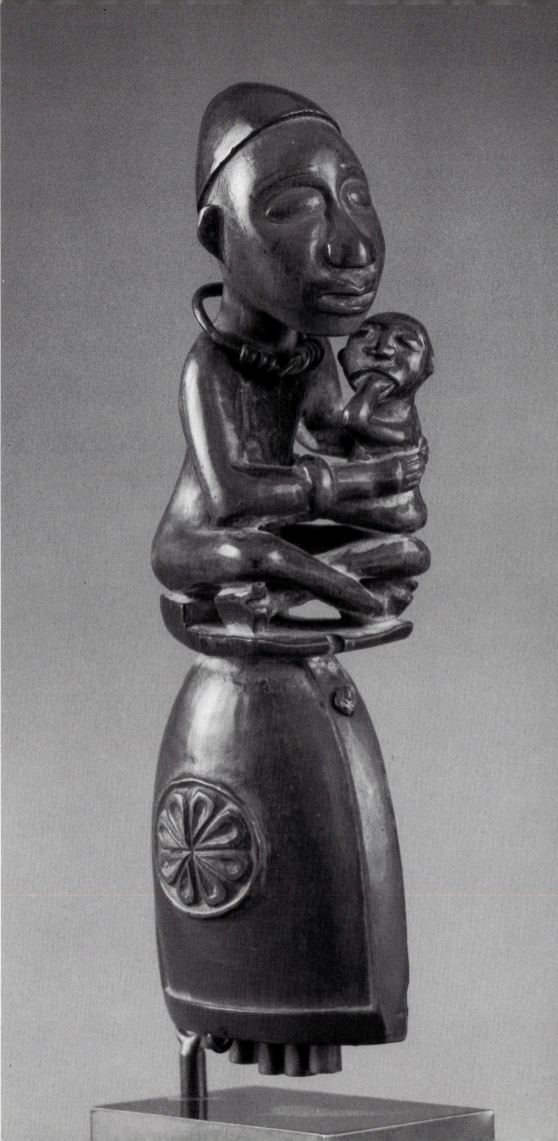

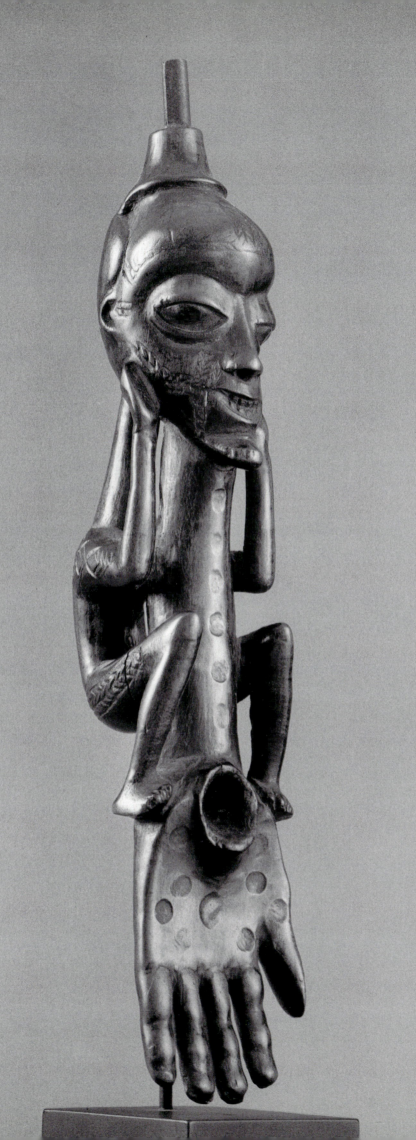

Man carrying a chief
Zaire, Tabwa
Wood, oil. H. 22 in.

In the ancient kingdoms of
southern Zaire, a ruler might
be carried on the shoulders of
a slave for ceremonial occa-
sions; he was so charged with
power his feet were never
permitted to come into direct
contact with the earth.

Power figure
Zaire, Songye
Wood, oil, leather, snake-
skin, cloth, fiber, fur.
H. 15 ¾ in.

In addition to the magical in-
gredients visible on the sur-
face of this figure, others are
hidden in cavities bored
down through the top of the
head, in the ears, the mouth,
the navel, and in other loca-
tions.

Altar to the Hand (Ikenga)
(not illus.)
Nigeria, Igbo
Wood. H. 37 ½ in.

Reliquary guardian (not illus.)
Gabon, Tsogo
Wood, pigment, metal.
H. 15 ¼ in.

Staff: female figure
(not illus.)
Zaire, Luba
Wood, beads, cloth, cowries,
metal. H. 25 ¼ in.

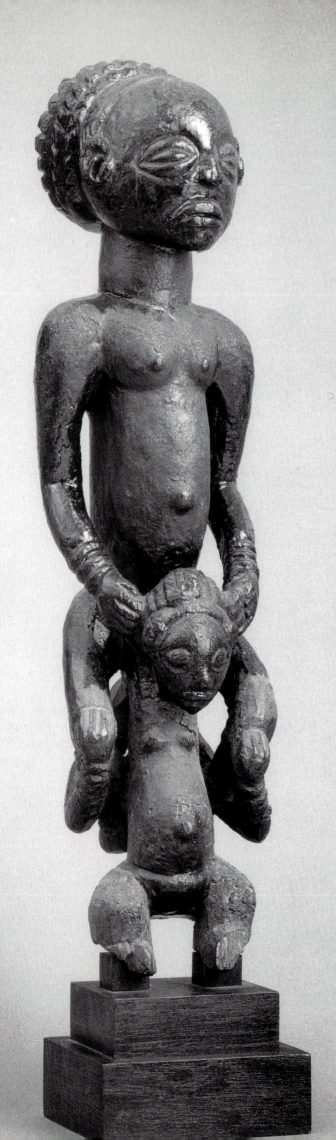

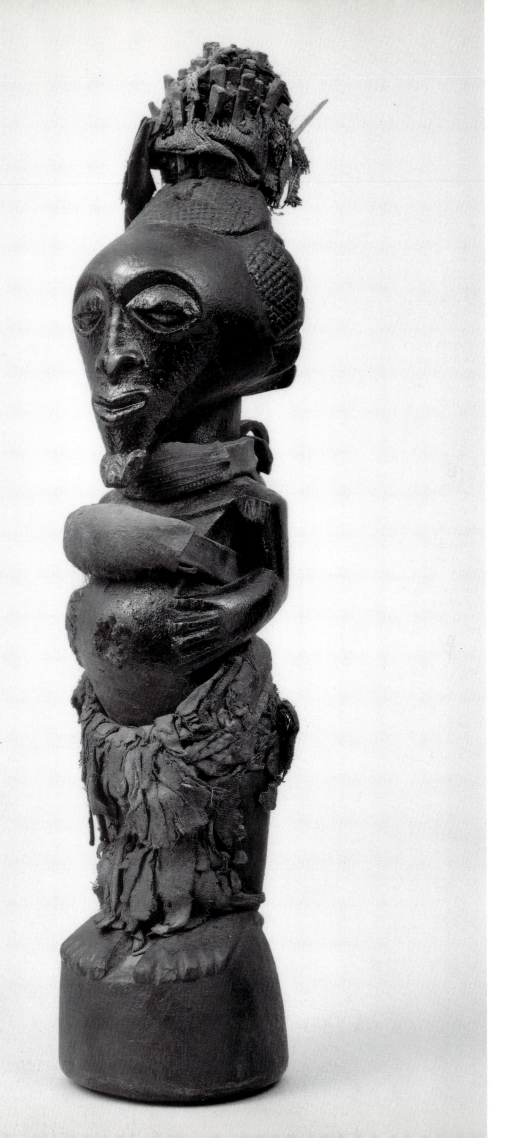

"We all know that collect-
ing is an obsession that has
compulsive aspects."

JOHN AND NICOLE DINTENFASS

Dr. John Dintenfass acquired his first piece of African art, a Guro mask, at the market place in Dakar, Senegal, where he was practicing transcultural psychiatry. The mask reminded him of Modigliani's paintings and, although Drs. John and Nicole Dintenfass' collection has undergone many changes in the twenty years since, the Guro mask remains in their collection as a memento of his "courtship with African art."

With the purchase of this first mask Dr. Dintenfass recognized he was embarking upon forming a collection. Not aware of its ultimate direction, however, he started collecting pieces from Nigeria, Cameroon and Liberia, regions familiar to him through his work. These early acquisitions came from Africans, traders, private collections and auctions. Between 1972 and 1975 he broadened his focus to include Zaire, Gabon, Angola and the Ivory Coast. While fulfilling his medical service in England, he acquired objects primarily through exchanges with European dealers and collectors, weeding and upgrading the collection as he went along. Through the influence of the painter Josef Herman, miniatures were added to the collection. In 1976, back in New York, the Dintenfasses concentrated on increasing the foundation and core of the collection and, in the most recent years, have added iron and bronze works to the collection.

Understanding the cultural context of a particular object has become less important to them throughout the years, and an attention to form has developed as their primary concern. Although the Dintenfasses do not believe that it is necessary for a collector to visit Africa, they consider themselves fortunate to have done so. "Visiting different cultures can enhance one's aesthetic appreciation of the culture and the art in action" he says. "To see the architecture and landscape and visualize how these are woven into cultural traditions helped me understand the art forms on a different level." The personal relationships established with cultural groups and regions as well as with individual Africans, he feels, have drawn him closer to African culture and enhanced his appreciation and understanding of the art forms.

For the Dintenfasses, one of the most enjoyable aspects of collecting is finding and adding interesting objects to their collection. The pleasure and emotion they derive from the forms of African art led them to collect it originally. They enjoy its "plasticity, and the warm medium of wood." The other great satisfaction is the "day to day enjoyment of the objects."

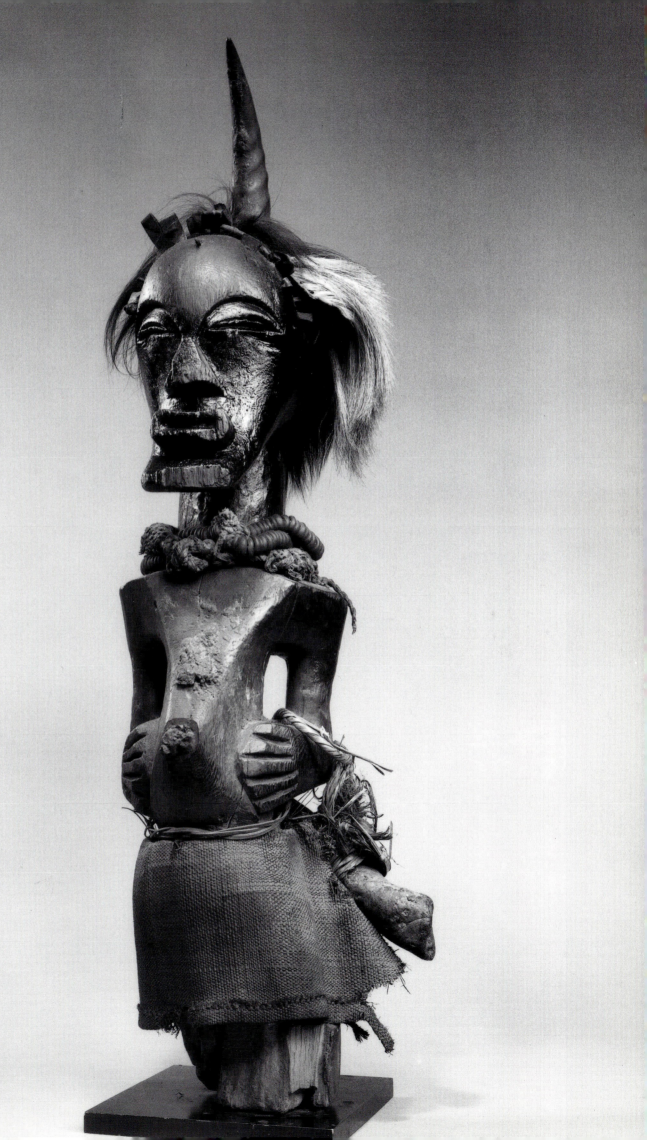

Power figure
Zaire, Songye
Wood, fur, beads, horns, rattan, raffia cloth, oil, metal. H. 26 in.

Such large power figures were used to protect entire communities. Certain individuals—specialists, healers, and practitioners of offensive and defensive magic—could set off its power by igniting a thin stream of gunpowder poured in a wide circle on the ground around it.

Mask
Ivory Coast, Dabakala
Wood, metal. H. 12 ½ in.

From the Senufo border area, this mask combines a basic element of Senufo face masks—the small legs at either side of the chin —with an original stylization of the face and coiffure.

Headdress
Nigeria, Ejagham
Wood, fur, metal, rattan, paint. H. 14 in.

The extreme naturalism of this headdress, with eyes that look as though they can actually see, is characteristic of the type. Its fur hat and its bare wooden surface are unusual.

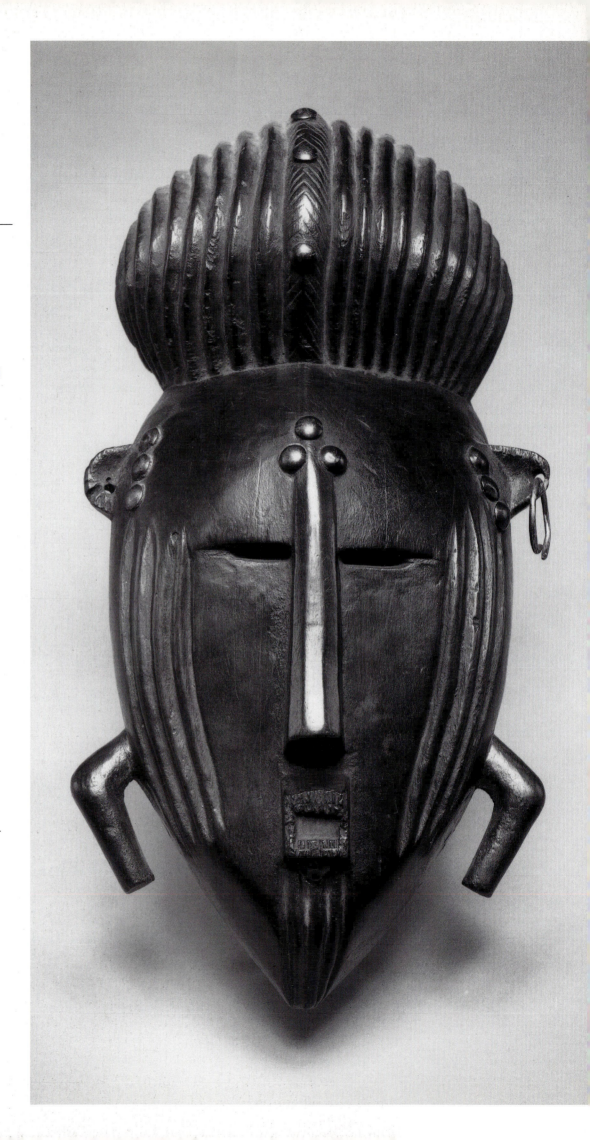

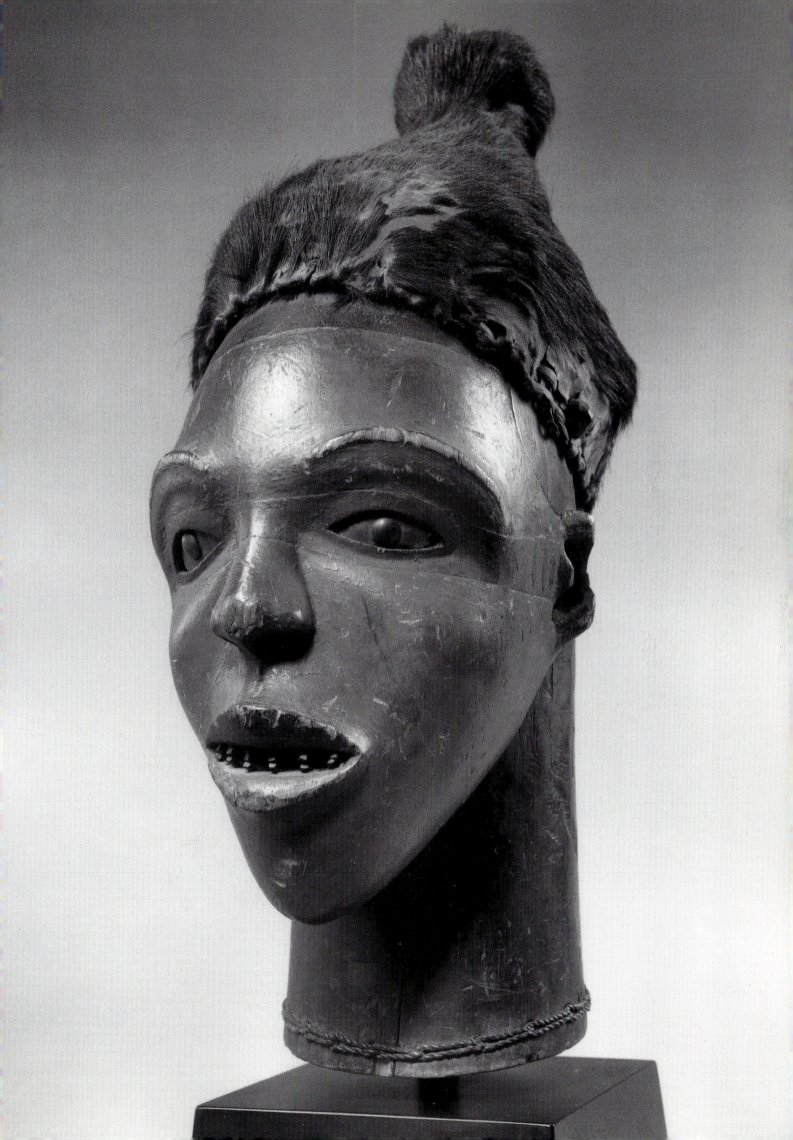

Female figure
Zaire, Zande
Wood, metal. H. 7 in.

Flowing circular forms fall in pairs from top to bottom in this small symmetrically composed figure. From the interlocking hooped earrings which dangle from either ear, to the bulging calves below, rounded forms are rhythmically repeated. Carved from sacred wood, consecrated, and then cared for in a small shrine outside the village, this figure would have protected members of a secret society from harm or misfortune.

Figure
Guinea-Bissau, Bidjogo
Wood. H. 14 in.

The abstract, minimalist form of this work is characteristic of Sudanic art. Though the Bidjogo live on a small group of islands off the coast of West Africa, their ancestors are believed to have migrated from the Western Sudan centuries ago, and Bidjogo art forms retain many Sudanic traits.

Mask (not illus.)
Gabon, Punu or Lumbo
Wood, pigment. H. 12 ½ in.

Pipe (not illus.)
Zaire, Mangbetu
Wood. H. 4 in.

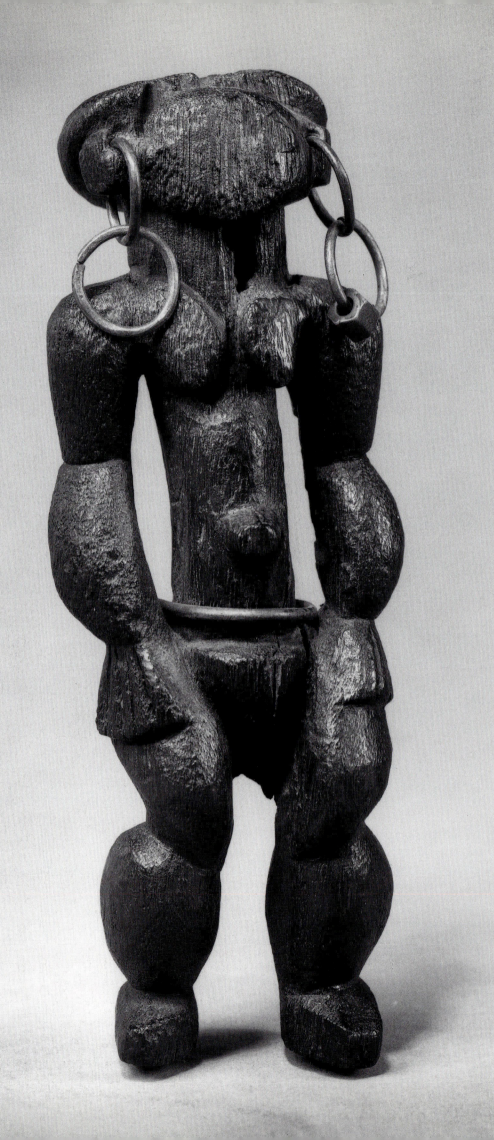

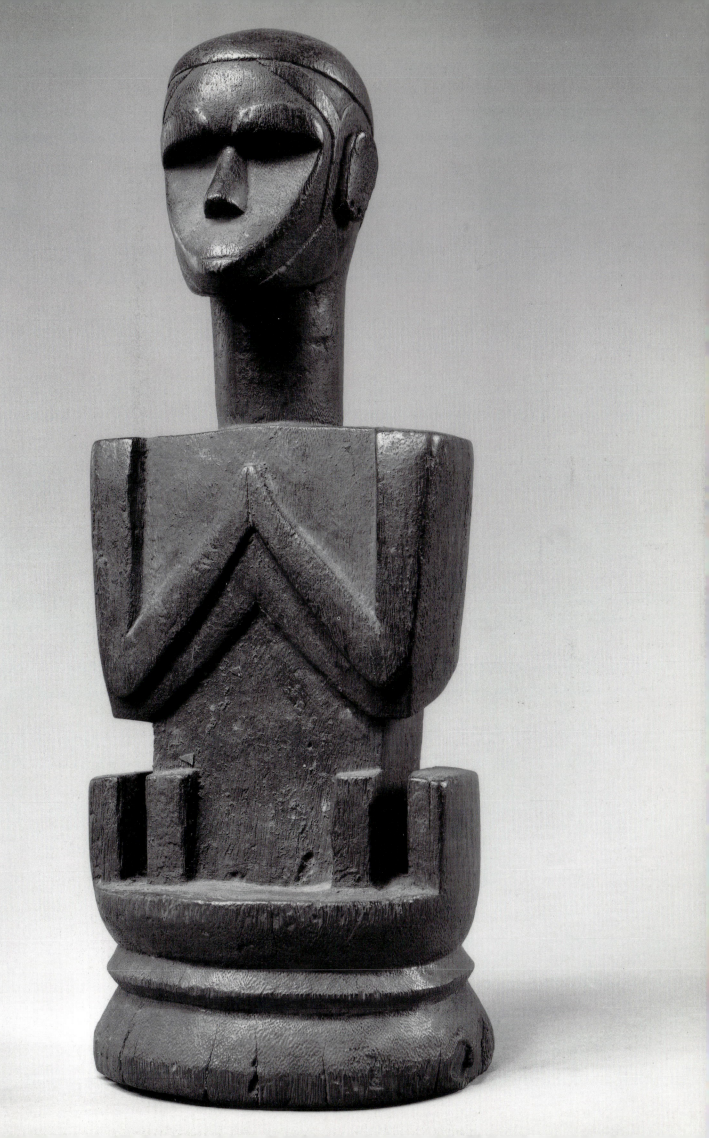

FRANKLIN AND SHIRLEY WILLIAMS

The Honorable Franklin H. Williams focuses his collecting "habits" specifically on the gold-weights of the Asante people of Ghana whom he came to know while he was America's Ambassador to Ghana. He began his collection, now numbering over 3,000 pieces, in 1961 at the market place in Accra Shana. The first purchases were made casually, acquiring three or four objects at a time, without the intention of starting a formal collection. Then, between 1966 and 1968 he began to acquire more weights while learning as much as possible about them. However, it was as late as 1981, after hundreds of sortings and re-sortings, that he realized that in these years he had established the foundations of his collection and, he says, "I concluded that certain pieces would never be given away."

Mr. Williams' initial interest in Asante goldweights derived from aesthetic "intrigue" and enjoyment of their beauty. Despite his own pleasure in "playing" with them, he is concerned that others, specifically Blacks, should have the opportunity to enjoy and learn from them as well. For this reason he is not only happy to lend his pieces to exhibitions but anticipates that his collection will end up in various Black college collections, specifically that of Lincoln University in Pennsylvania.

The advice that he gives to new collectors of goldweights is to read as much as possible, visit museums, and talk to anyone who seems to know more about the subject than you do. He also advises caution when acquiring objects; the greatest dangers of collecting are the fakes offered for sale by galleries or "so-called experts." He considers it important to avoid these dangers by understanding the overriding aesthetic which dominated Asante culture. When asked if collecting African art is like eating peanuts (you can't take just one), Mr. Williams says it's not possible to stop after only one, and, besides, "some of them are peanuts."

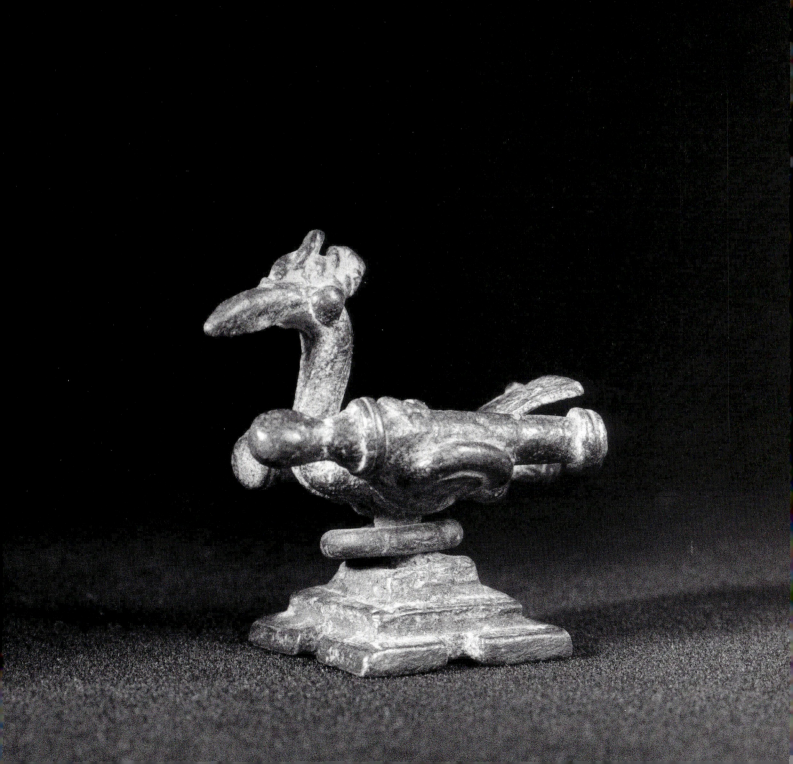

Goldweight: bird with cannons on wings from a group of six animal weights
Ghana, Asante
Bronze. H. 1 ⅜ in.

Birds are a frequent subject for weights; this bomber-like image is surely a statement about power.

Boxes for gold dust from a group of ten
Ghana, Asante
Bronze. L. 2 ½ in. (largest)

Gold dust, used as currency, was carried in small lidded boxes cast from the lost wax method or made of repoussé brass sheets.

Goldweights: shield, knot, strainer, horn
Ghana, Asante
Bronze. 3 in. (largest)

Weights depicting manmade objects constitute a kind of selective inventory of Asante material culture. Also common are fascinating weights cast directly from natural objects such as insects, nuts, seeds and chicken's feet.

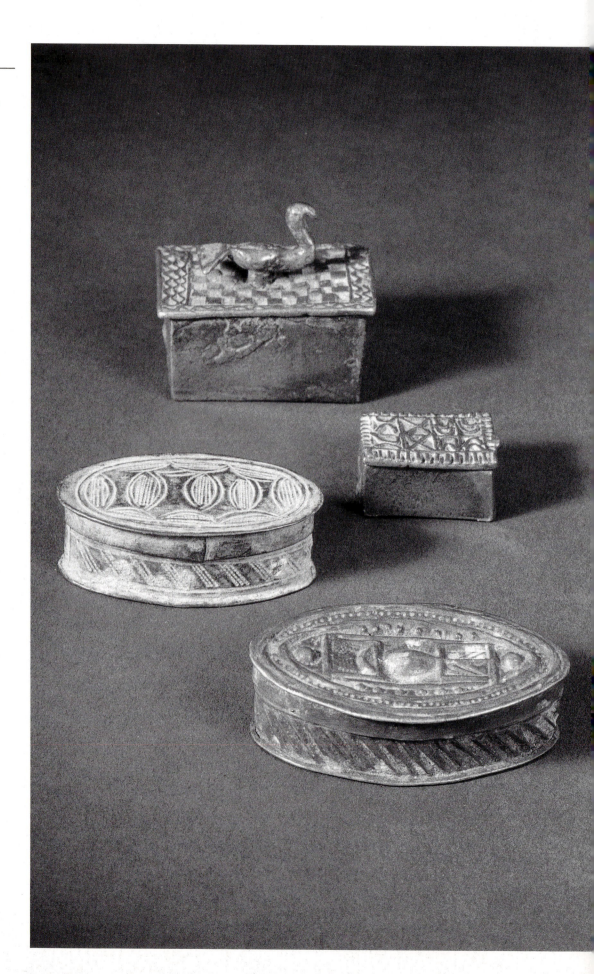

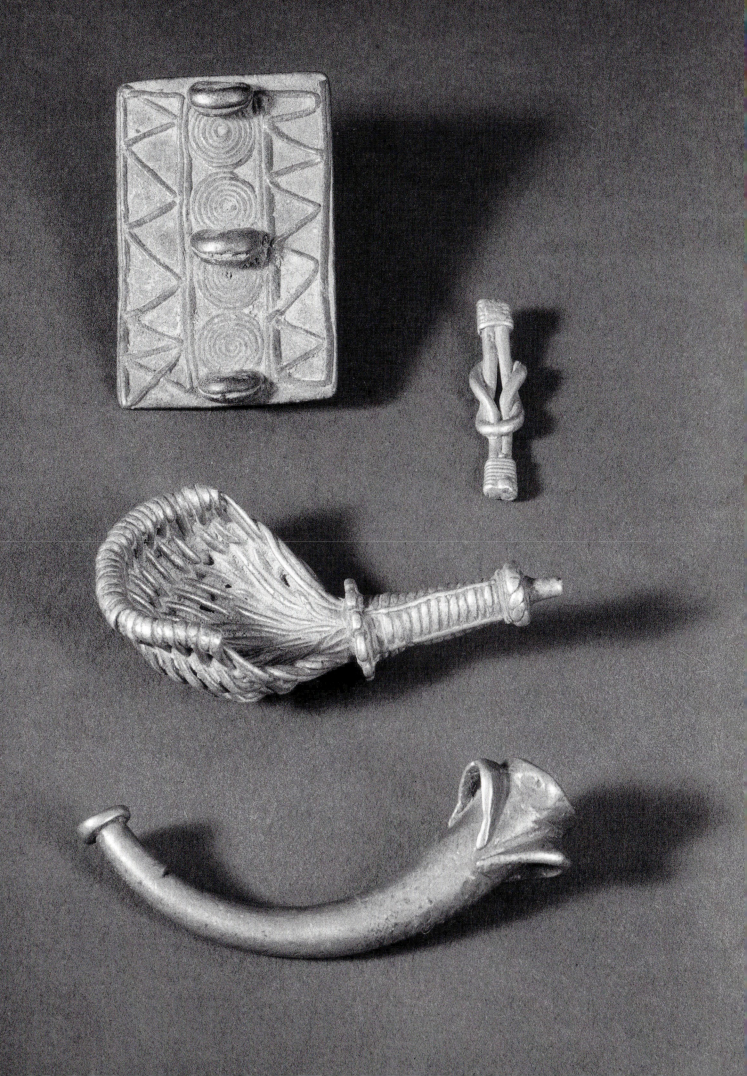

Goldweight: mother and child from a group of five figurative weights
Ghana, Asante
Bronze. H. 2 ⅜ in.

A miniature masterpiece sculpture like this one has all the presence and invention of a full size African sculpture. Some of the same conventions are observed such as the mother's boldly non-anatomical arm.

Goldweights: six swastika weights from a group of ten
Ghana, Asante
Bronze. H. 2 ¼ in. (largest)

The swastika in myriad variations is a common motif in gold weights. It is related to stylized bird motifs but its meaning is unclear.

Goldweights cast from life
(not illus.)
Ghana, Asante
Bronze, 3 in. (largest)

Spoons and scales for gold dust (not illus.)
Ghana, Asante
Bronze. 5 in. (largest)

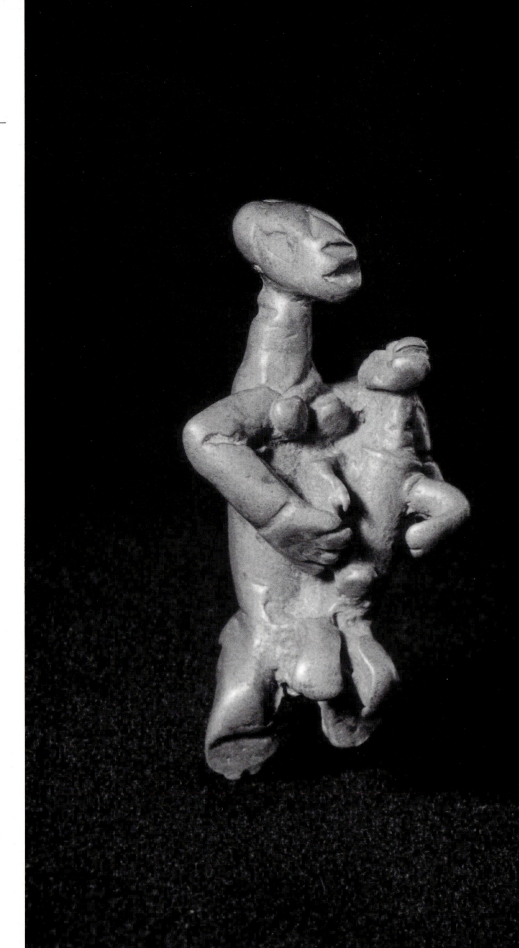

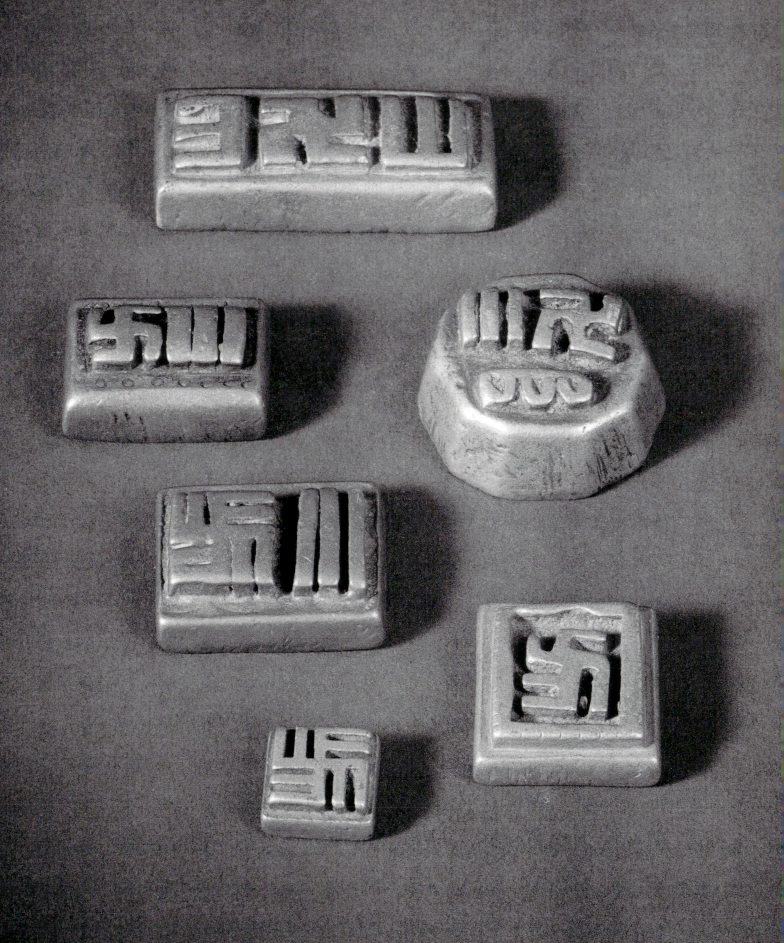

ERNST ANSPACH

Ernst Anspach began his collection with an impulse purchase of a Bamana "doe with a young buck on her back", shortly after his son was born in 1936. The piece is still in his large collection which today numbers over four hundred and fifty objects. He acquired African art most intensively between 1962 and 1975, but it was in 1959, when he began to sell objects from his collection of Twentieth Century art to finance his African purchases that he realized he was forming a serious collection. Today, he says, he has kept some Twentieth Century sculpture, a few paintings and "some incunabula from earlier incarnations as a collector." The dynamism of African art and its lack of a market orientation drew him to collect it rather than other things, though his wife tolerated his collecting with little enthusiasm.

He has never been to Africa and doesn't think that going is very important to collecting. For Mr. Anspach, the African context is not important at all for an understanding of the objects except where it helps to inform him about the probable authenticity of an object. Over the years, he has gone for advice to the literature, to scholars and museum curators. He feels his collection has evolved from the most accessible objects, those closest to Western aesthetics (such as those in the Baule, Senufo and Bamana styles), to objects that are more "African", as he puts it. To a new collector, he would say, "either learn something about what you are doing or pay for such knowledge by buying only from the most reputable sources." The biggest pitfalls, he says, are "to collect for someone else's approval, social prestige, or investment."

The greatest satisfactions of collecting he says, "are to live with one's collection, and to find objects of merit in unexpected places or where they have been overlooked by other collectors." Like many collectors, he lends to exhibitions reluctantly because, in his words, "getting long in the tooth, I don't like to have my objects where I can't see them for any length of time." For Mr. Anspach, the worst experience of an African art collector is the viewing of collections formed by people without taste or knowledge who, because they have been successful in their business, believe they can buy bargains.

As for the future of his own collection, he expects that it will have to be sold "to support my widow for what I hope will be long years of modest comfort."

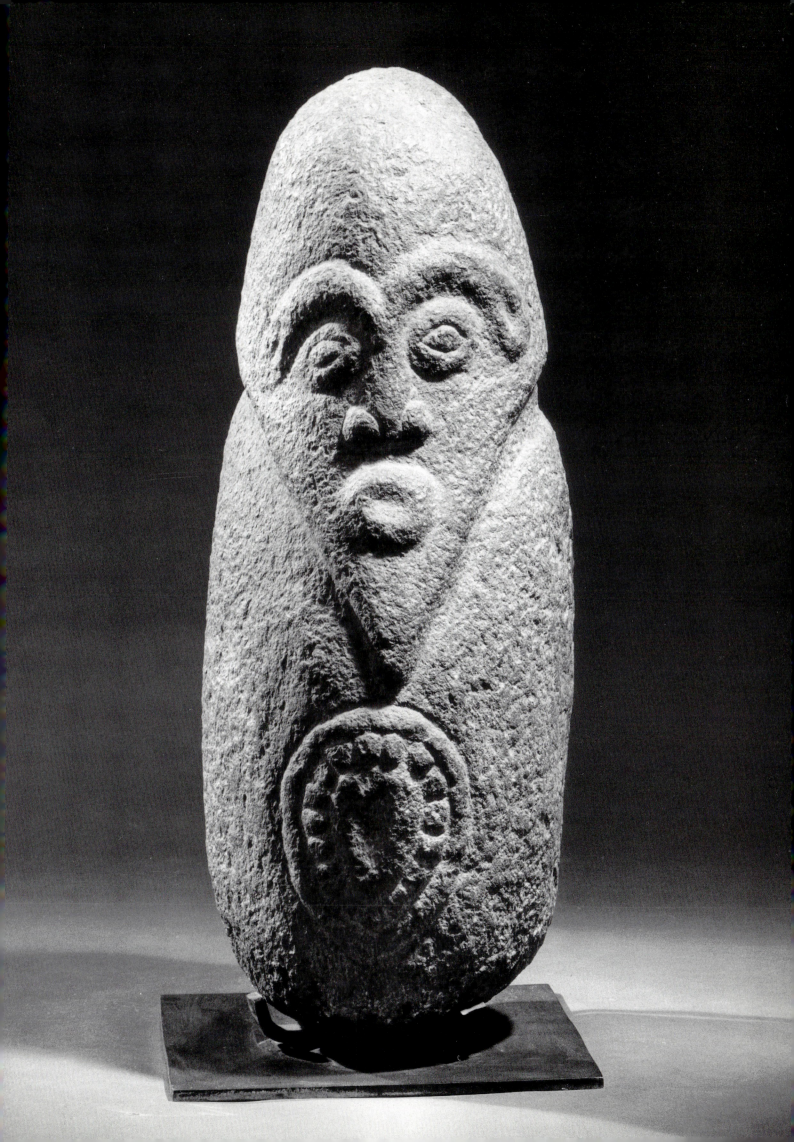

Memorial effigy (Akwanshi)
Nigeria, Ejagham
Stone. H. 22 in.

This sculpture is one of a group of approximately three hundred monoliths produced centuries ago in the region presently inhabited by the northern Ekoi. It once stood together with others, its lower section embedded in the earth.

Face mask
Zaire, Kongo
Wood, paint, fur, nails.
H. 10 in.

The naturalism of this mask is typical of Kongo art (both masks and figurative sculpture), which is one of the most naturalistic of all African art styles.

Face mask
Northern Zaire
Wood, pigment, hair.
H. 8 ½ in.

How this mask was used is not known. It comes from northern Zaire where sparse masking traditions are related to those of the Central African Republic.

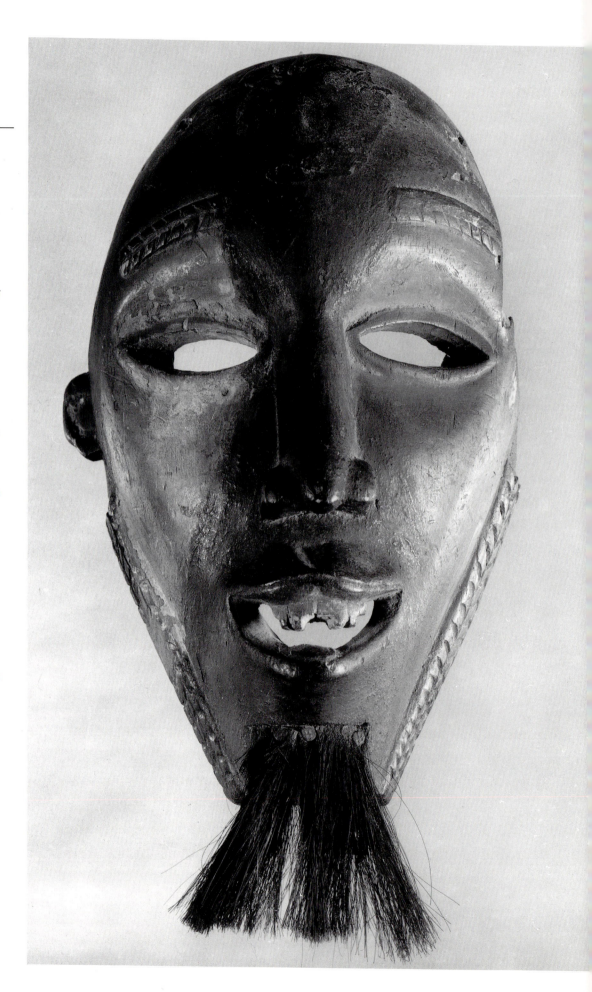

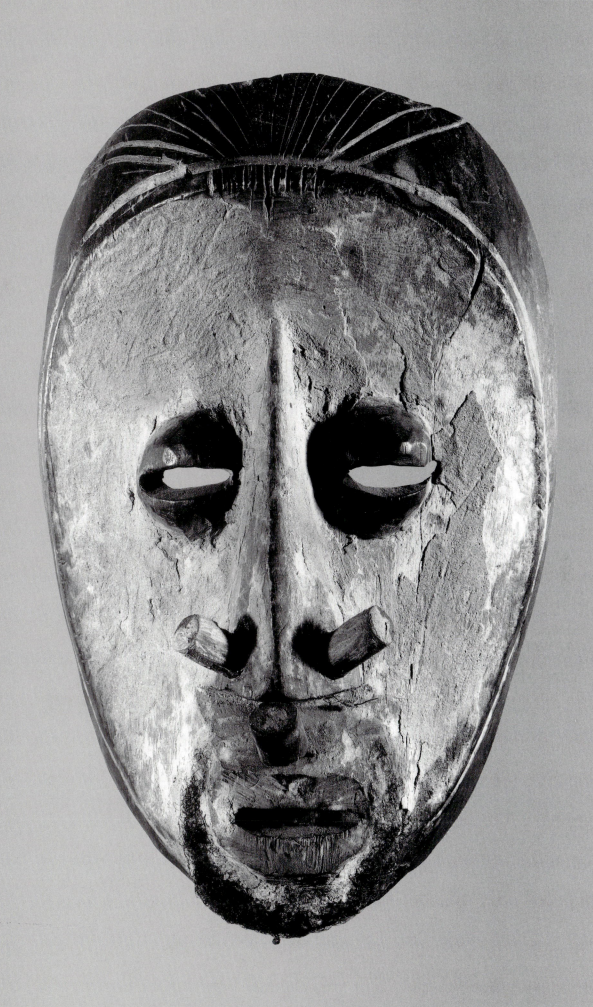

Double figure
Cameroon, Mambila
Stone, pigment. H. 14 in.

Among the Mambila, stone sculpture is very rare. No other work in this configuration is known; its use and meaning are unknown to us.

Monkey mask
Zaire, Hemba
Wood. H. 8 in.

This mask represents a chimpanzee-human. When it performed at funerals its costume included black and white Colobus monkey hair, a monkey hair beard, and a red barkcloth cape with animal skins dangling below. The wide upturned curve of its mouth inspired great fear and its wild performance terrified spectators. Its armless form and the cacophony it produced contributed to its horrific aspect. Women and children ran from it and men did not look it in the eye.

Antelope headpiece
(not illus.)
Mali, Bamana
Wood. H. 19 in.

Power figure (not illus.)
Zaire, Kongo
Wood, resin, feathers, mirror, cloth. H. 10 ½ in.

Janus figure (not illus.)
Zaire, Songye
Wood, fur, beads, raffia cloth, pigment. H. 30 in.

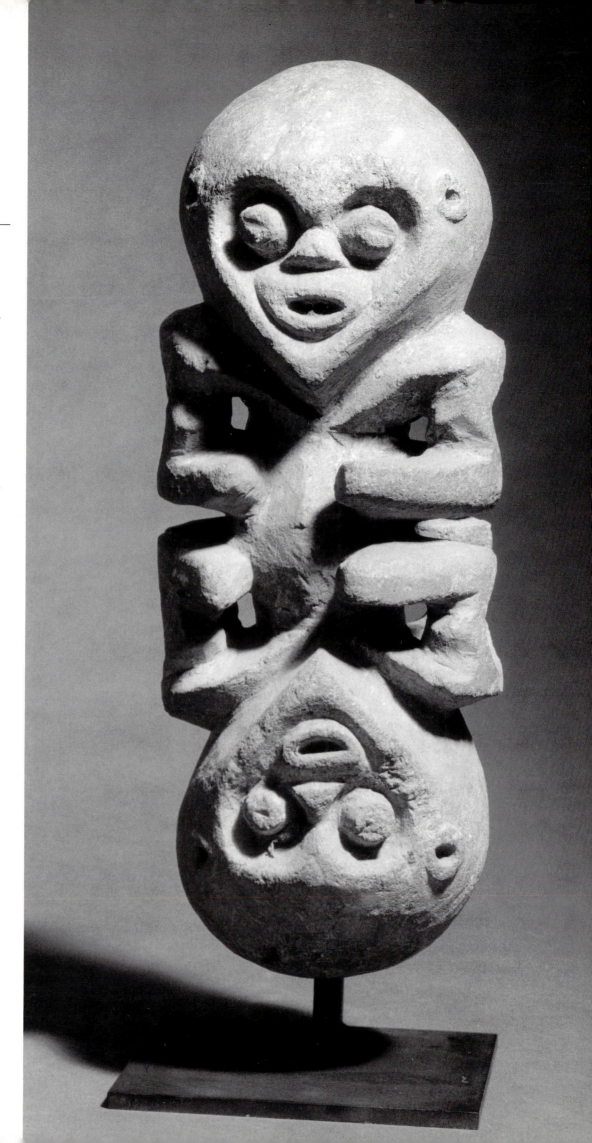

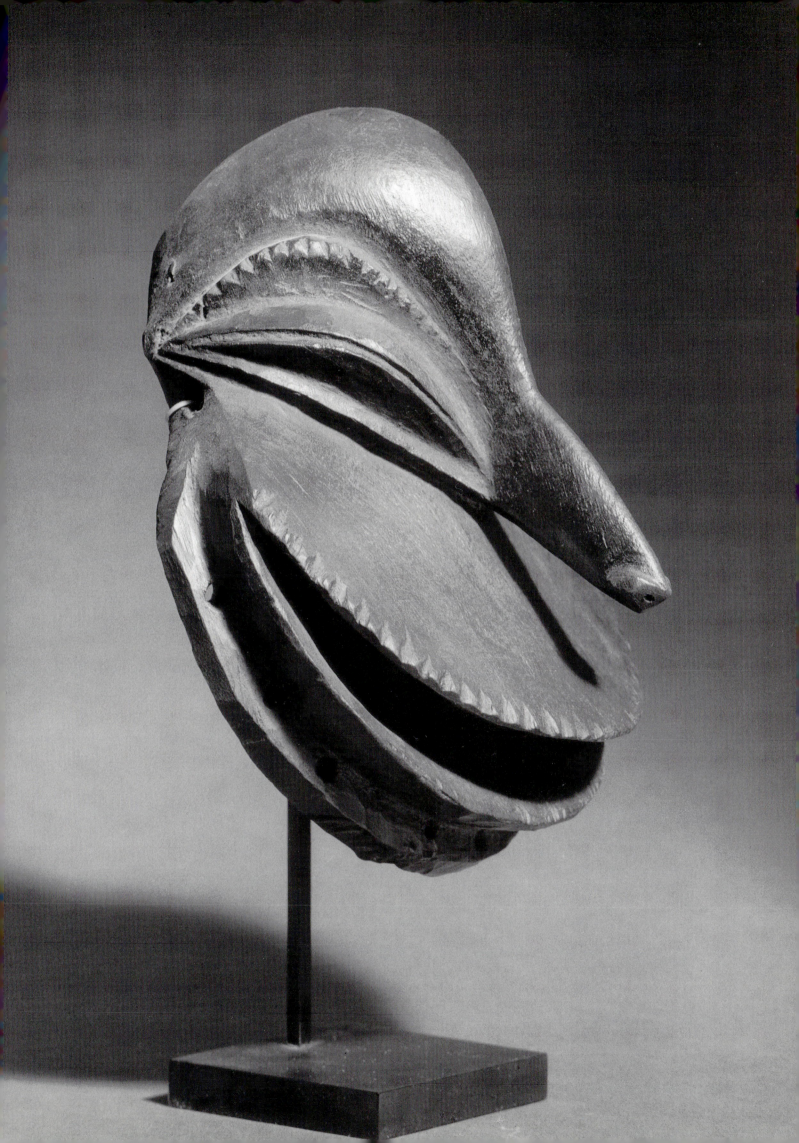

JEAN AND NOBLE ENDICOTT

As experienced art collectors, Drs. Jean and Noble Endicott have accumulated the approximately two hundred objects in their African collection through personal aesthetic attraction to specific forms of African art. In selecting particular objects they have considered the form of the work and their response to the piece as the paramount guidelines for enhancing their collection.

The Endicotts were originally collectors of Nineteenth Century American art. Their first acquisition of an African object was an isolated purchase in 1968 at auction of a Guro pulley, which they considered at the time a purely decorative object. This was five years before they started purposefully collecting African art, but the pulley is still in their collection. Between the years 1975 and 1983 the Endicotts acquired the largest number of pieces per year. Not certain of specific reasons why African art appealed to them more than other forms of art, they have decided it was "probably because of its expressive power."

While strongly guided by their own judgment, the Endicotts also believe that in order to avoid certain pitfalls of collecting, such as purchasing expensive pieces that are not authentic, it is prudent to seek the advice of knowledgeable dealers and fellow collectors. They also believe that it is important to expose oneself to as much material as possible before purchasing, and to buy only from a "reputable dealer to whom you can return the object if there is good evidence that it is not authentic." A great risk in collecting, Dr. Endicott believes, is being blinded by your enthusiasm for an object, and becoming financially overextended for the love of a great piece.

The Endicotts are ambivalent about lending their objects to exhibitions. They understand the value of exhibitions, but are unhappy about living without their objects for long periods of time. Ultimately, they hope that after living with their collection for many years to come, it will be sold at auction so that other collectors may enjoy the objects as they have enjoyed them—as an integral part of their lives.

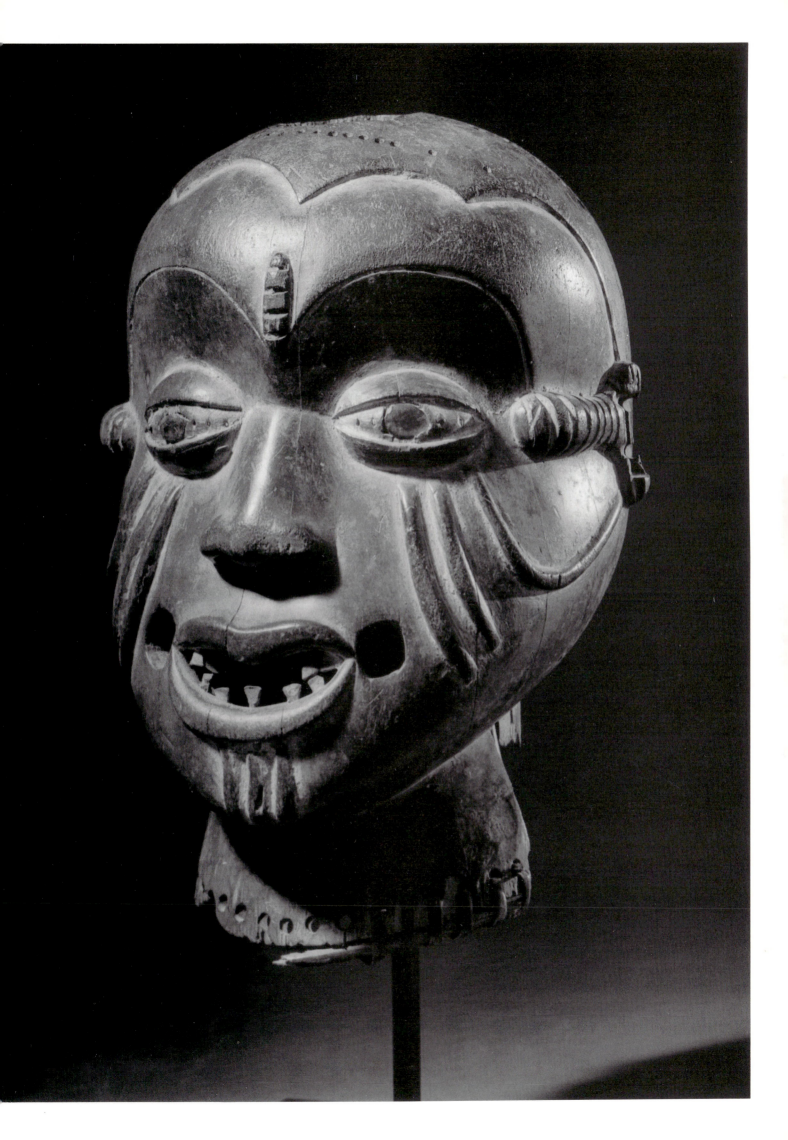

Headdress
Nigeria, Boki or Ejagham
Wood, fiber. H. 9 ½ in.

From the Cross River region where the art forms of neighboring groups have inspired one another, the form and function of this work are related to the skin-covered crests used by the Ekpe society among the Ekoi.

Power figure
Zaire, Kongo
Wood, fur, mirror. H. 12 in.

This figure has been stripped of the additive materials which once constituted its power.

Face mask: bird head
Ivory Coast, Senufo
Wood. H. 13 in.

Such face masks performed at funeral celebrations honoring an important elder. The mask's presence added an element of feminine beauty to a performance which included the contrasting beastly forms of "firespitter" masks. The head and beak of a bird depicted above the forehead represents the hornbill. Its red head compared to the red hats of elders, the hornbill is referred to in songs which metaphorically honor the creativity and intelligence of senior members of the Poro society.

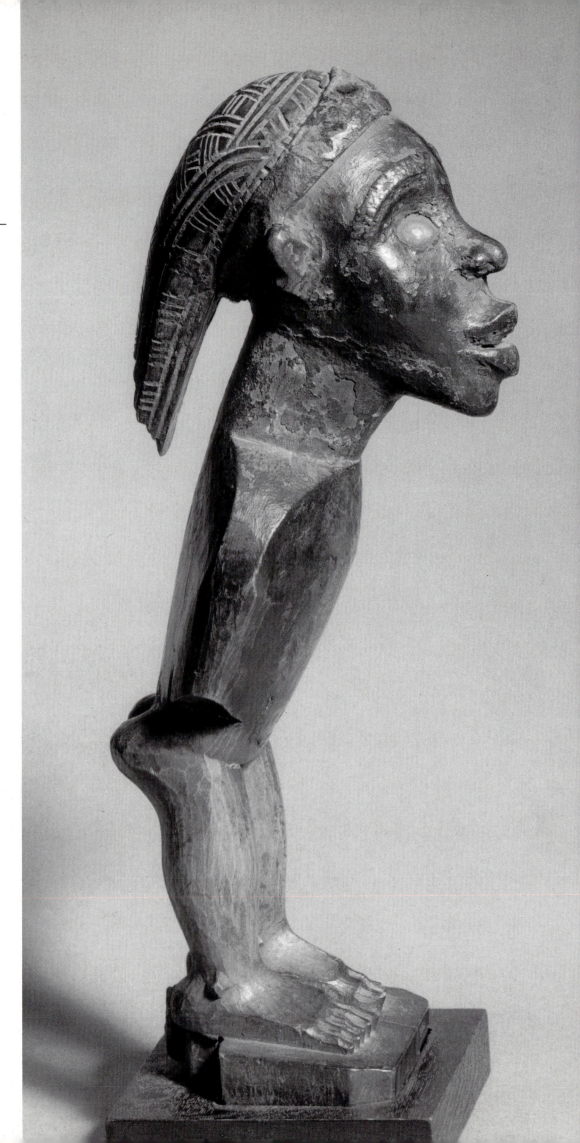

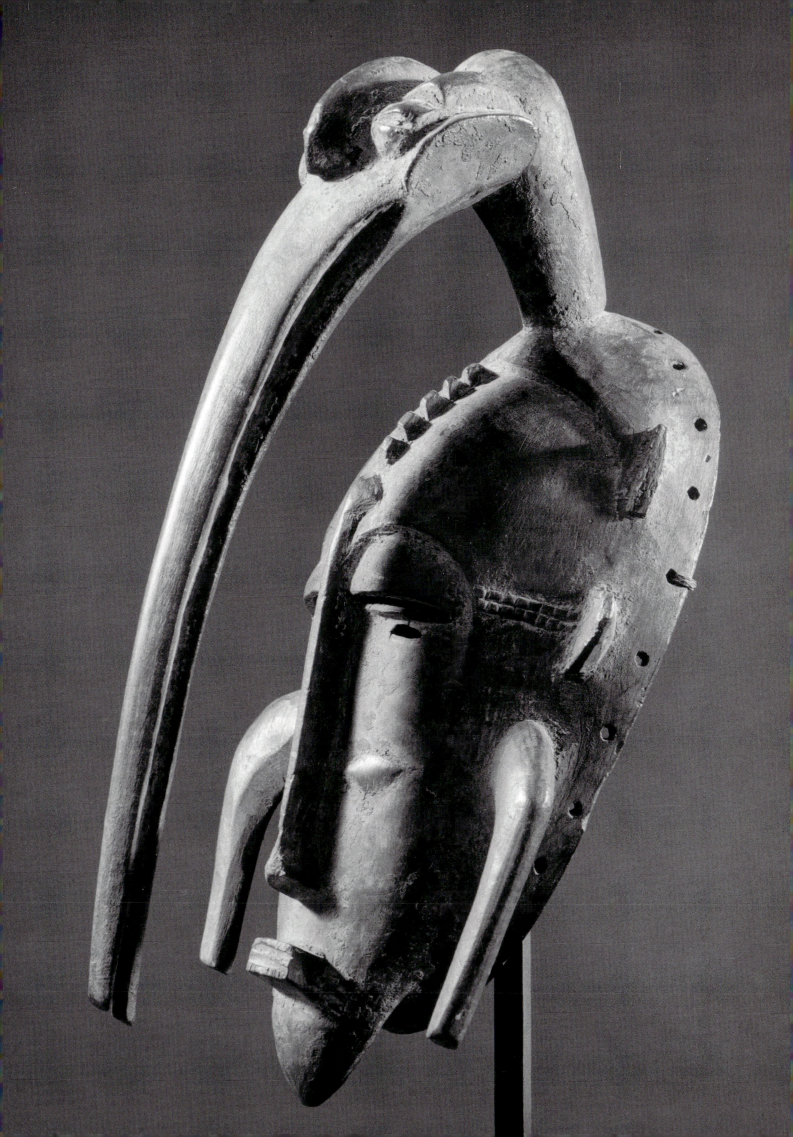

Seated figure
Sierra Leone, Nomoli style
Stone. H. 4 ½ in.

Figures and heads in several
styles are found in the earth
in present-day Sierra Leone
and adjacent parts of Liberia
and Guinea. They appear to
have been made before the
mid-sixteenth century by peo-
ples of the now vanished Sapi
kingdoms comprising today's
Baga, Bullom, Temne, Kissi,
and other ethnic groups.

Female figure
Mozambique, Makonde
Wood, cloth. H. 8 ⅜ in.

This delicately carved figure
displays the scarification and
lip ornament worn by Ma-
konde women. Most African
figurative sculpture was not
shown undressed in its origi-
nal context; this sculpture still
wears a cloth skirt.

Figure: raised arms (not illus.)
Ivory Coast, Lobi
Wood. H. 7 ⅞ in.

Shango staff (not illus.)
Nigeria, Yoruba
Wood. H. 18 ¼ in.

Mask (not illus.)
Mozambique, Makonde
Wood, pigment, metal, hair,
wax. H. 10 in.

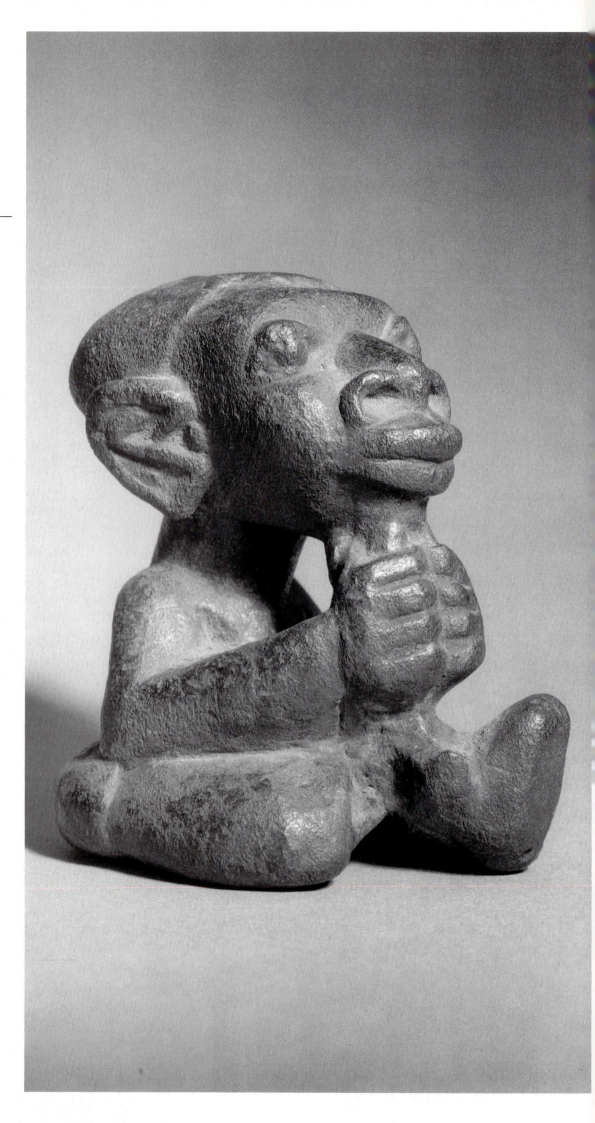

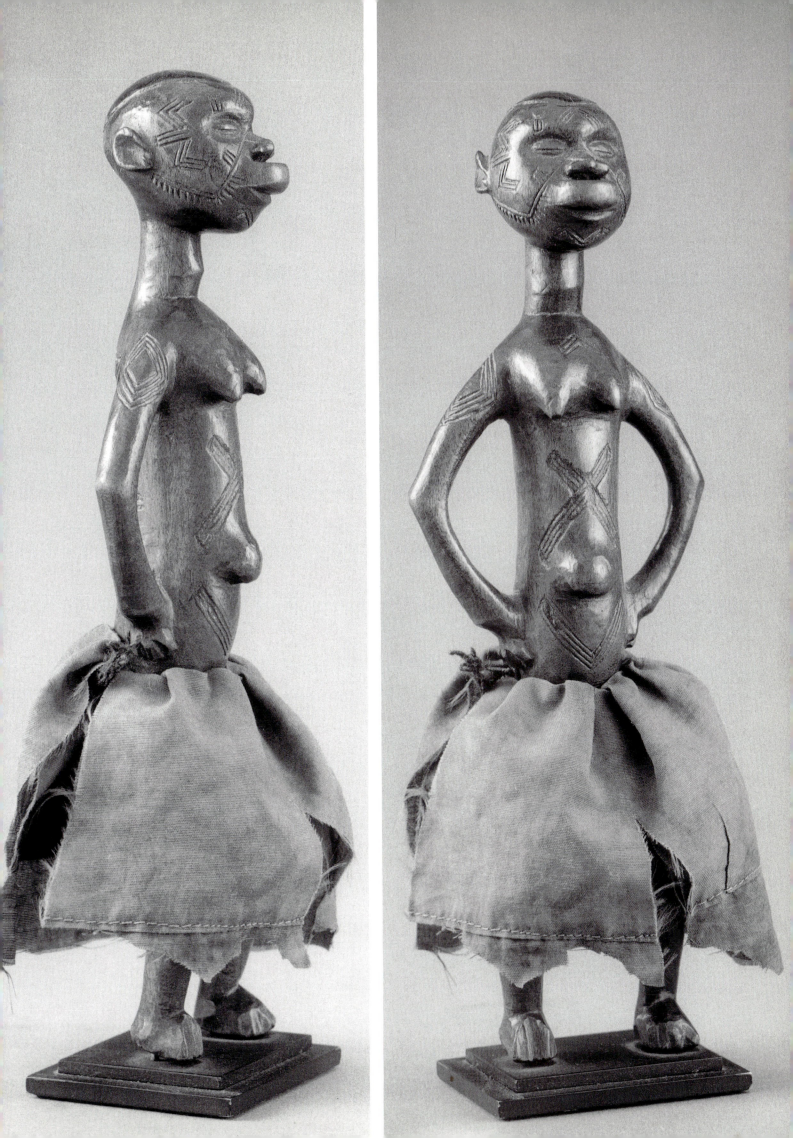

GASTON T. deHAVENON

Gaston deHavenon formed his collection of over fifty pieces of African art during the years 1956 to 1978 in which he collected intensively. The first piece Mr. deHavenon acquired was a Bamana antelope headdress from Mali. From this point on, he realized that he wanted to form a collection of African art consisting of pieces from nearly all of the peoples of Africa.

Before becoming interested in African art, Mr. deHavenon collected Post-Impressionist Nineteenth Century painting and Twentieth Century paintings and sculpture. In 1954 Mr. deHavenon was introduced to African art through a friend and became passionately interested in the field. Through his experience with Twentieth Century sculpture he was first attracted to Dogon sculptors, who he thought were the greatest artists of all. He then decided, however, to collect all types of African art, guided primarily by his attention to aesthetics, and by the rarity of the object.

Mr. deHavenon's experience in collecting had already exposed him to antiquities, painting and sculpture collections in many museums throughout the world. Following this example, Mr. deHavenon visited the "Primitive" art collections of these museums, and pursued books and scholarship in the field. As important as it is for Mr. deHavenon to know and understand the meaning of the objects, he also believes that he has been gifted with a special eye for collecting, and it is this eye that enabled him to spot the great works of African art he was able to acquire for his collection.

Mr. deHavenon has strong words of advice for the new collector. He stresses the importance of acquiring few pieces of great quality rather than buying many mediocre pieces, and especially, buying from a reputable dealer whose taste is acknowledged and who has many years of experience. When asked what he believes will eventually become of his collection, Mr. deHavenon refuses to think too far into the future: "For the present, I am happy to live with it and enjoy being surrounded by the beautiful sculpture of Africa."

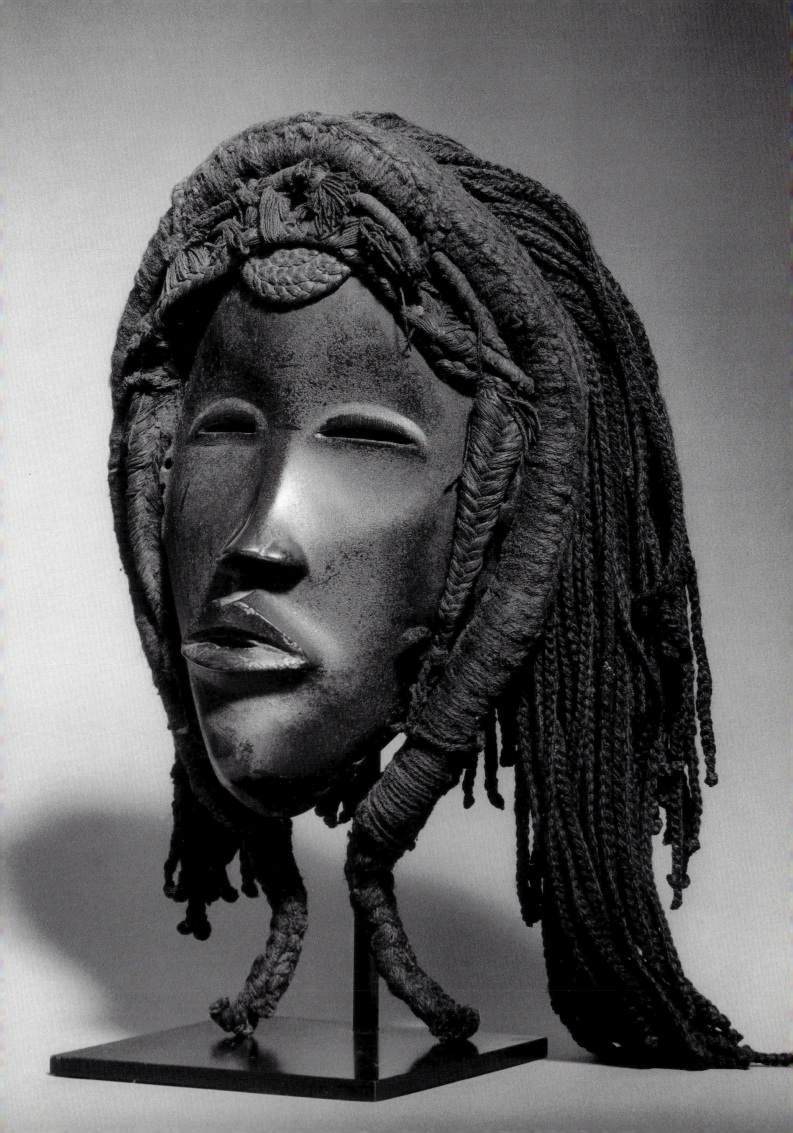

Female mask
Ivory Coast, Dan
Wood, fiber. H. 12 ¼ in.

Dan masks with slit eyes de-
pict females and are worn by
singers and dancers who per-
form for the entertainment of
the village. They also repre-
sent beautiful young women
and, during periods of initia-
tion, visited the village in the
evenings collecting food from
mothers for the boys who
were spending time in the
forest initiation camp.

Figure: hands to face
Mali, Dogon
Wood, sacrificial material.
H. 10 in.

According to previously pub-
lished Western interpretations
of Dogon myth, this figure
represents Dyougou Serou,
the first human being created
by the god Amma. Not hav-
ing a wife, Dyougou commit-
ted the sin of incest with his
own mother, the earth. Dy-
ougou here hides his face in
shame.

Mask: goat head
Ivory Coast, Baule
Wood, metal. H. 12 ¼ in.

This mask belongs to the cat-
egory of masks called *ngblo*
which appear in the village
for entertainment dances of a
predominantly secular nature.
These small human face
masks may be seen by wom-
en whose active participation
in music making and in the
dance is essential. In Baule
mask classification, the *ngblo*
are thus associated with
women and with the village,
whereas the sacred masks are
associated with men and with
wild untamed nature.

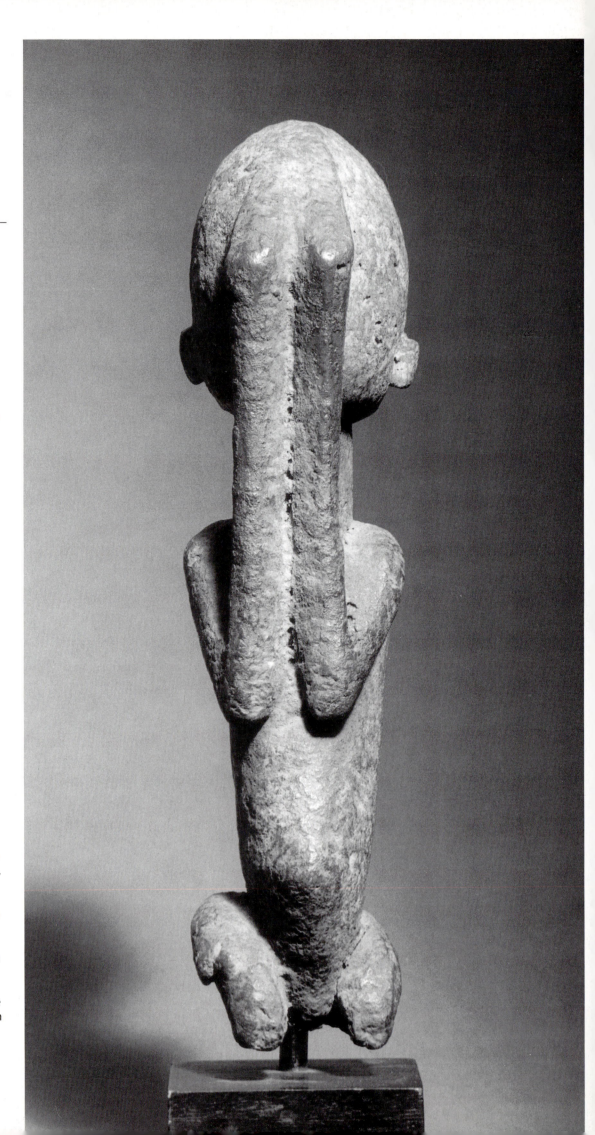

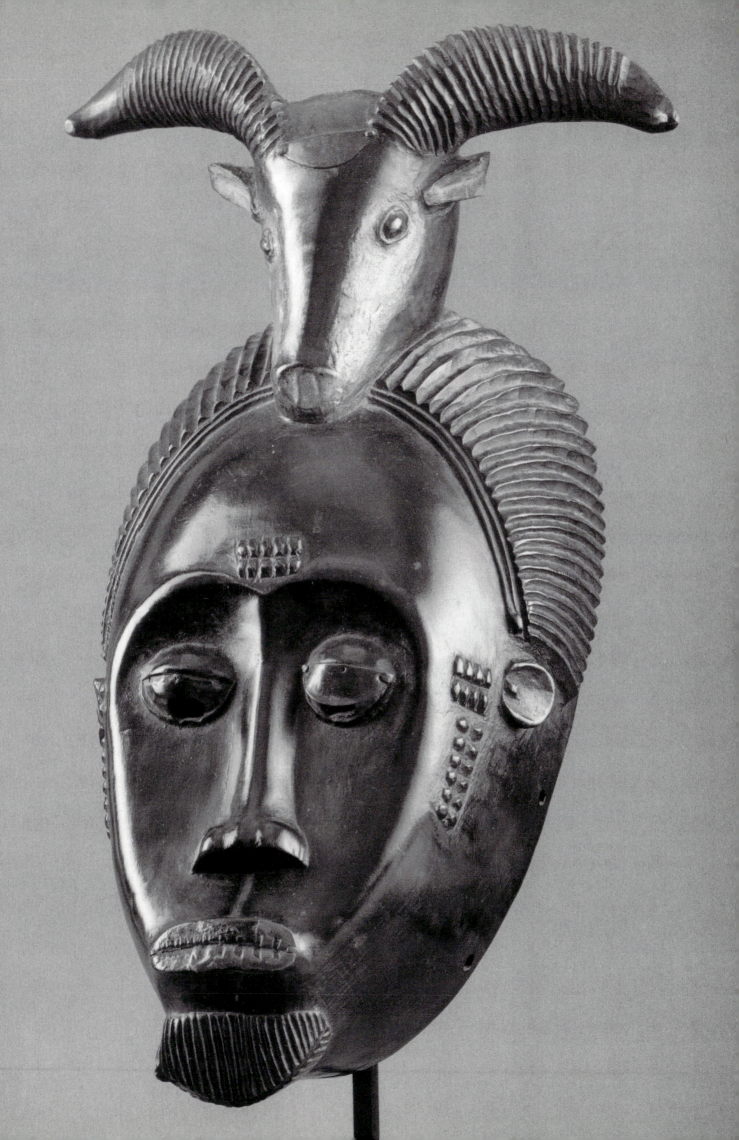

Mask: female figure
Mali, Dogon
Wood. H. 23 in.

Though masks surmounted by
standing female figures,
called *satimbe,* are well
known, this mask surmounted
by a seated female figure is
extremely unusual.

Stool: caryatid
Nigeria, Yoruba
Wood, metal. H. 18 ⅜ in.

This female figure wears a
long slender lip-plug, an or-
nament that has gone out of
fashion among the Yoruba of
the twentieth century. Marks
of beauty and indicators of
status, lip ornaments were
common during the nine-
teenth century and exist in
other parts of Africa to this
day.

Multi-headed figure
(not illus.)
Mali, Dogon
Wood. H. 14 ¼ in.

Mask: female figure
(not illus.)
Burkina Faso, Mossi
Wood. H. 21 in. (figure only)

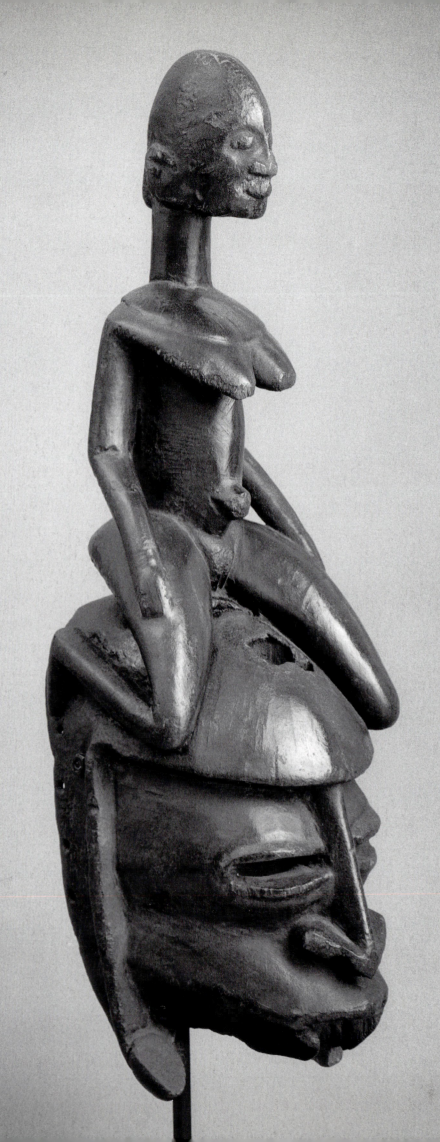

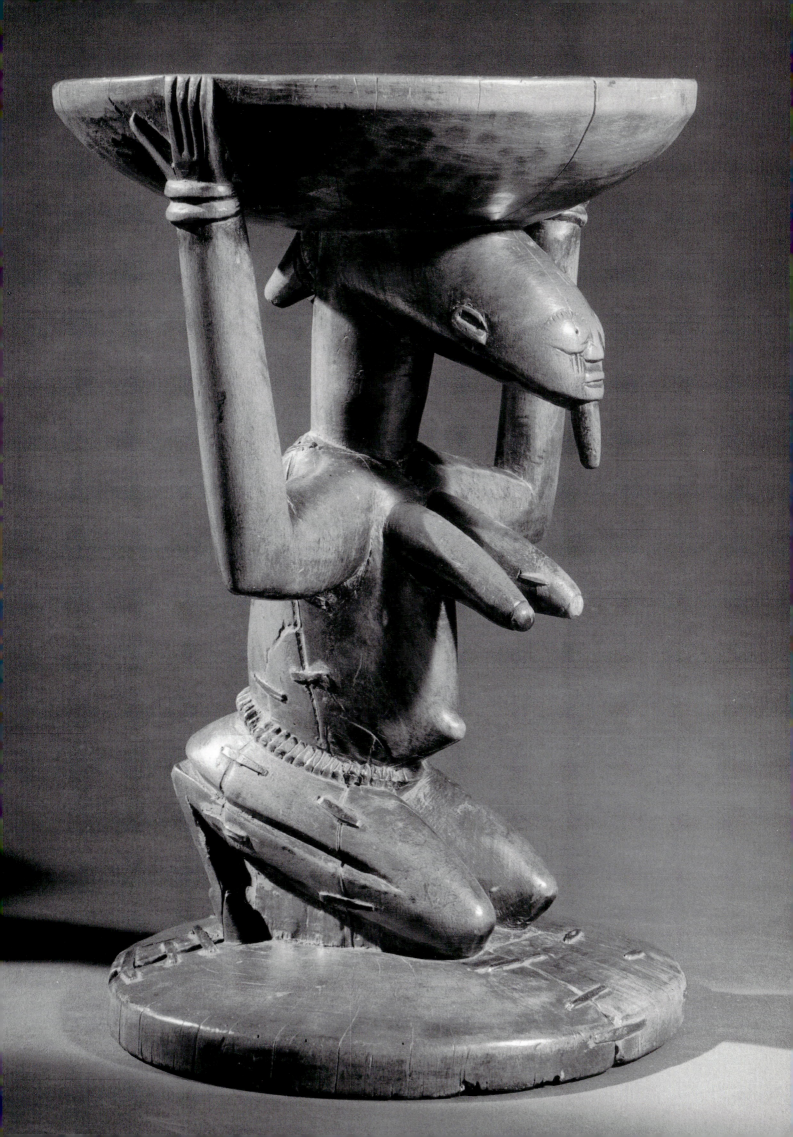

BRIAN AND DIANE LEYDEN

Mr. and Mrs. Brian Leyden consider "pure form and artistic excellence" to be the driving force behind their collection. They began to acquire African works in 1974 and now have about two hundred pieces, all from the Ivory Coast. "From 1974 to the present," Leyden says, "I have collected with much excitement, but in terms of actual pieces acquired, 1979 to 1984 would be the halcyon period."

In 1977, their experience of Alfred Scheinberg's exhibition, "Treasures of the Ivory Coast," resulted in focusing their collecting exclusively on the art of this country. Within this region, their personal preferences "revolve around the human figure." They have developed their collection steadily—at first without even being aware that a collection was forming.

In terms of their original interest in African art, they consider it a "logical extension of aesthetic growth" from their "awe" of the Surrealist and Cubist artists. The first piece that Mr. Leyden acquired was, in a sense, accidental. In 1972, while hunting for American antiques in Blue Ball, Pennsylvania, he found an abstract Makonde figure that appealed to him very much. As it turned out, the piece was of "modern vintage" and, although he has not been willing to part with his first African acquisition, Mr. Leyden says the figure "enjoys a place of honor in my basement, surrounded by other abstractions from the 'boiler age,' including water heater, furnace, etc."

This first experience with African art reveals a touch of the romantic nature that Mr. Leyden feels goes hand in hand with his collecting. Further evidence of this can be heard in the reasons he gives for feeling that going to Africa is not necessary to his collecting. He views his objects, he says, as being conceived in the pre-colonial aesthetic that he admires. He adds that "if Addidas sneakers and Sony Walkmen were absent from the Ivory Coast, I might reconsider my position, but, at present, my romantic vision of pre-colonial Ivory Coast is too fragile to tamper with."

Mr. Leyden believes that the best way to learn about objects is to see as many "superb" objects as possible, create a good reference library, and do your "homework." With this already in mind, the advice that he gives to new collectors is to "go for quality, resist quantity." The advice that he gives to others is strictly followed by the Leydens themselves in all aspects of their collection whether it is Twentieth Century Surrealist sculpture or sculpture from the Ivory Coast.

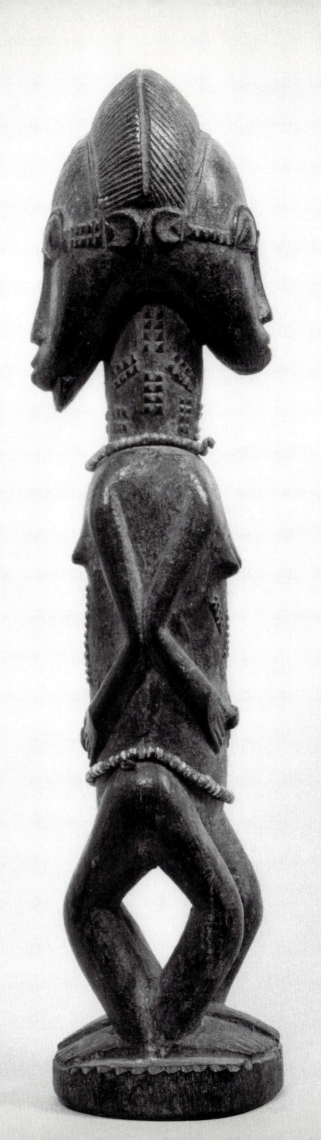

Janus figure
Ivory Coast, Baule
Wood, beads. H. 14 in.

Baule janus figures are virtually unknown but one can surmise that this one was for bush spirits and was used by a diviner.

Funerary figure
Ivory Coast, Anyi
Terracotta. H. 11 ½ in.

Commemorative terracotta figures, made by women in the Anyi area around Krinjabo, formed tableaux in special groves (never at the burial place) where offerings to the dead could be made and devotions carried out. The figures were said to be portraits of individuals, recognizable by certain characteristic features.

Male figure
Ivory Coast, Guro
Wood, pigment. H. 22 ½ in.

Called "small wooden people" by the Guro, figures like this represent messengers of a protective spirit. If a diviner has discovered it to be the spirit's wish, a sculpture is created and placed in a special shrine with other manifestations of the protective spirit, such as vessels filled with powerful ingredients.

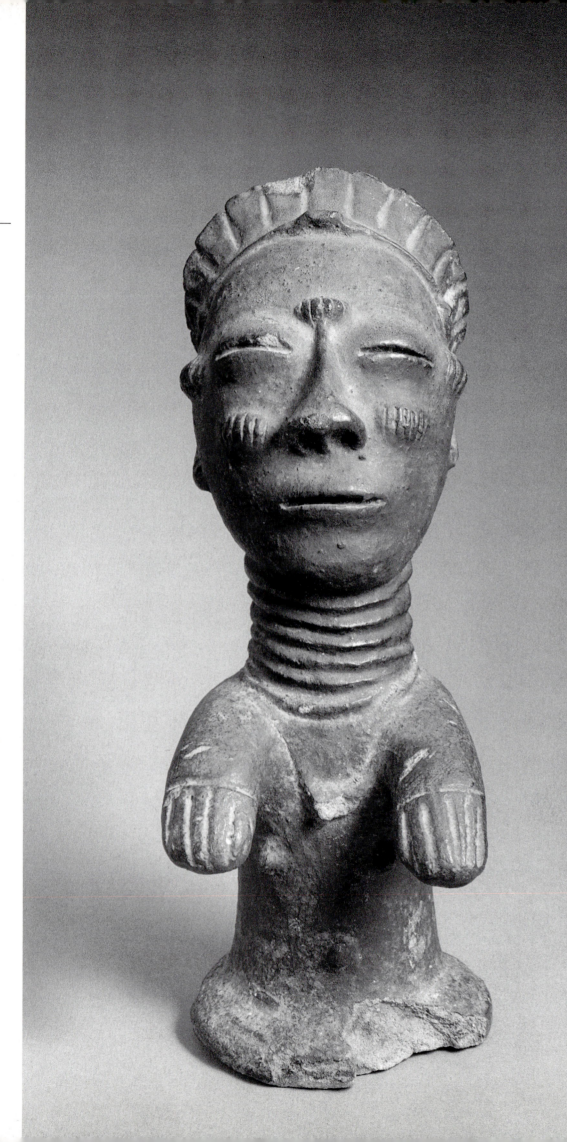

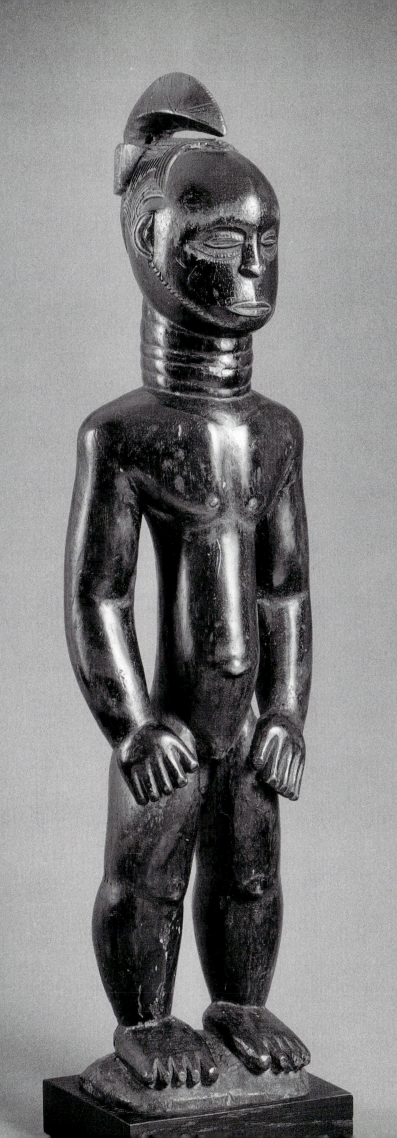

Female figure
Ivory Coast, Baule
Wood, beads. H. 20 in.

The extraordinary pointed coiffure of this figure connects it to art from the Kulango and Abron peoples of the northeast, but the style of the face and body are pure Baule.

Standing figure
Ivory Coast, Jimini
Wood, beads. H. 19 ½ in.

Pulleys and a few figures exist in this striking geometric style in which the body is composed of neatly separated elements.

Male figure (not illus.)
Ivory Coast, Baule
Wood, beads. H. 16 ¾ in.

Comb (not illus.)
Ivory Coast, Akan
Wood. H. 7 ½ in.

Face mask (not illus.)
Ivory Coast, Senufo
Wood. H. 10 ¼ in.

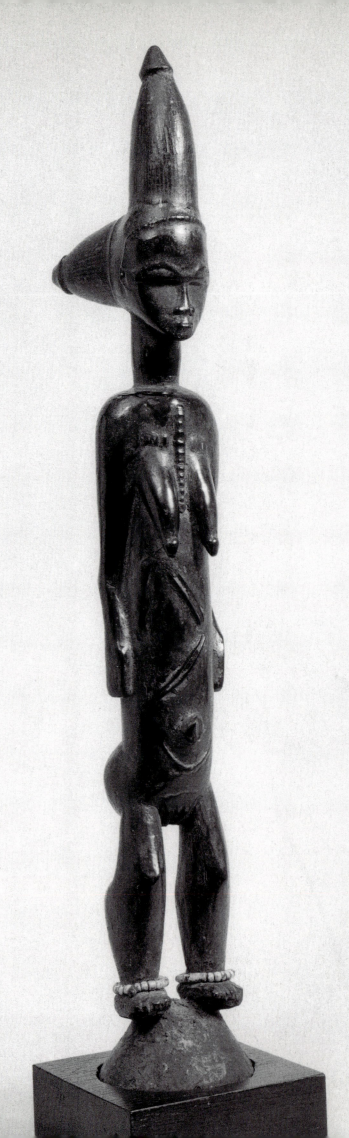

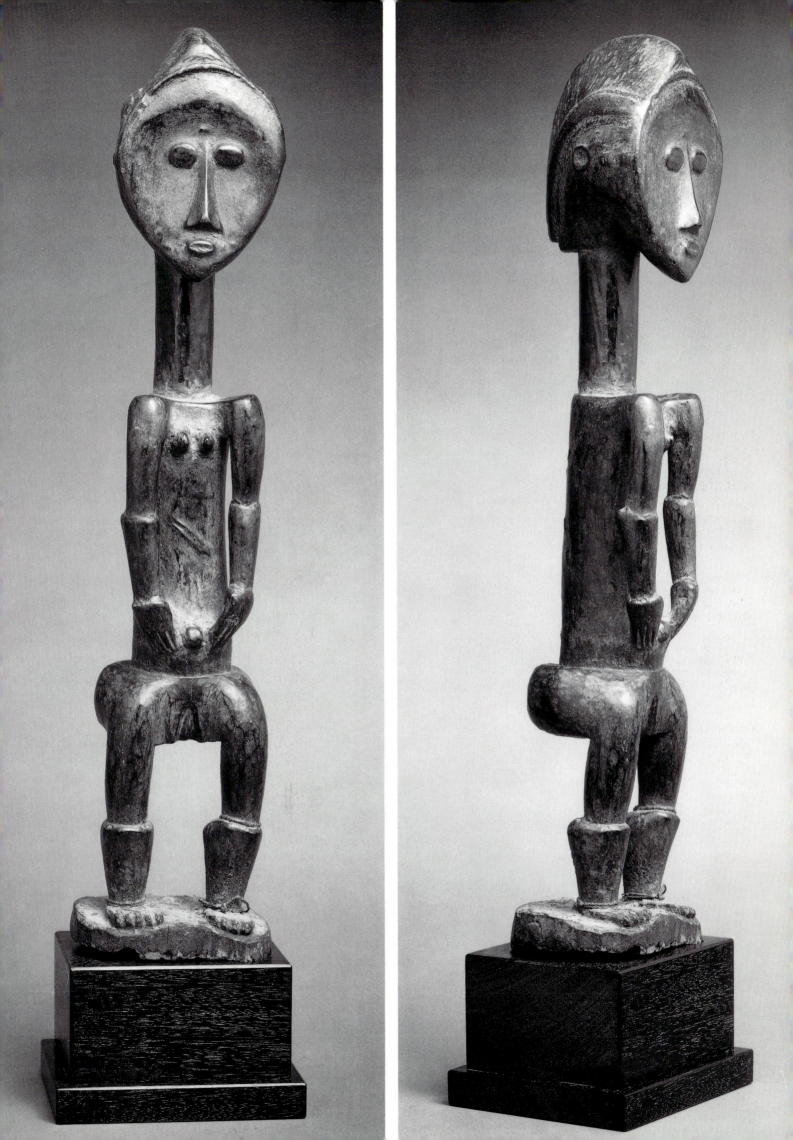

INDEX OF ILLUSTRATIONS